HOW TO DRAW
ALMOST EVERYTHING

Quarto is the authority on a wide range of topics.

Quarto educates, entertains and enriches the lives of
our readers—enthusiasts and lovers of hands-on living.

www.QuartoKnows.com

Original Japanese edition published by SEIBUNDO SHINKOSHA PUBLISHING CO., LTD
English language licensed by World Book Media LLC, USA via Tuttle-Mori Agency, Inc.,
Tokyo, Japan.
English translation and production by World Book Media LLC
Email: info@worldbookmedia.com

First published in the United States of America in 2016 by
Quarry Books, an imprint of
The Quarto Group
100 Cummings Center
Suite 265-D
Beverly, Massachusetts 01915-6101
Telephone: (978) 282-9590
Fax: (978) 283-2742
QuartoKnows.com

10

ISBN: 978-1-63159-140-2

Translator: Ai Toyoda
English Language Editor: Lindsay Fair

Printed in China

HOW TO DRAW
ALMOST EVERYTHING

AN ILLUSTRATED SOURCEBOOK

CHIKA MIYATA

QUARRY

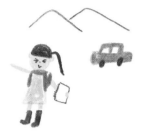

Introduction

I was inspired to create this book after a friend confided that she could not draw as well as she wished whenever her kids asked her to draw pictures for them. Like my friend, many people get confused and frustrated when they draw. Maybe they're not sure where to start, or maybe they doubt their abilities.

To help my friend and others like her, I have developed a simple technique that breaks down every illustration into basic steps. Once you get started, you'll see how fun drawing can be. In fact, I feel that this book teaches you to enjoy drawing more, rather than how to draw better.

As a professional illustrator, I spend almost every day drawing. I always bring my sketchbook along wherever I go because you never know when you'll be presented with the opportunity to draw something new. Just like with any skill, the more you practice, the more you'll improve your abilities.

Please use this book as a reference whenever you're wondering how to draw a particular image. Keep it nearby whenever you draw. I've also included several "challenges" to help develop your skills along the way. Now grab a pencil and let's get started!

Contents

INTRODUCTION 4

GETTING STARTED 8

Materials 8

Warm Up: Practice Drawing Lines 12

Warm Up: Practice Drawing Shapes 13

How to Use This Book 14

ANIMALS 15

Terrestrial Animals 16

Aquatic Animals & Fish 31

Birds 42

Bugs & Insects 48

Dinosaurs 54

Challenge #1: Draw a Zoo 60

Unidentified Mysterious Animals 62

PEOPLE 65

Faces 66

Expressions 68

Actions 69

People by Age & Gender 70

Clothing 84

Occupations 88

Famous Faces 94

PLANTS 97

Trees 98

Shrubs 102

Flowers 105

Other Unique Plants 112

FOODS 113

Fruits 114

Vegetables 118

Main Dishes 126

Snacks 136

Drinks 141

Challenge #2: Draw Bottles 141

Packaged Foods 142

Challenge #3: Draw Food Packaging 143

Challenge #4: Make a Food Journal 144

AROUND THE HOUSE 145

Entryway 146

Kitchen 147

Living Room 152

Bedroom 154

Study 155

Bathroom 156

Patio 159

Home Maintenance 160

Challenge #5: Draw Windows and Doors 160

ARCHITECTURE AND SITES 161

Around the Neighborhood 162

Challenge #6: Draw a Street Map 167

Famous Sites in Japan 168

Famous Sites Around the World 171

VEHICLES 177

On the Road 178

On the Tracks 192

In the Air 195

Challenge #7: Draw Vehicles and Landscapes 198

On the Water 200

Other Vehicles 205

SEASONS 209

Everyday Events 210

Challenge #8: Illustrate Your Date Book 211

Holidays & Seasonal Events 212

Weather 215

Chinese Zodiac 218

Astrological Signs 219

Challenge #9: Draw Scenes from Your Favorite Movies 220

Challenge #10: Animal Alphabet 221

AUTHOR'S NOTE 222

ABOUT THE AUTHOR 223

Materials

This guide introduces the various drawing materials used in this book. Choosing the correct drawing instrument is important because it influences the syle of your drawing, but not to worry...there are so many options available today. I recommend that you experiment with different materials in order to find your favorites.

Materials Key

Look for these icons on the first page of each chapter. They indicate which drawing material was used for each category of illustrations. Use the suggested material to replicate the illustration in the book, or experiment with your favorite drawing supplies.

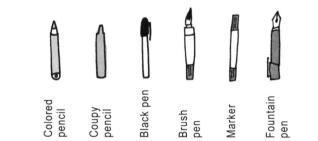

Colored pencil Coupy pencil Black pen Brush pen Marker Fountain pen

Colored Pencils

Staedtler Ergosoft: Hard lead. Good for small details.

Royal Talens Van Gogh: Beautiful color.

Holbein Artists': Wide range of colors available. Can be used with Holbein Meltz to create watercolor effect.

Faber-Castell Polychromos: My favorite black colored pencil.

Coupy Pencils

Sakura Coupy Pencil: Woodless colored pencil with the brilliance and texture of a crayon.

Black Pens

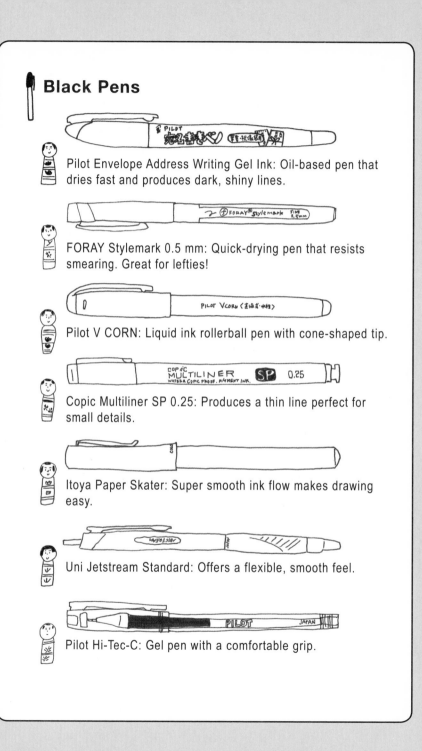

Pilot Envelope Address Writing Gel Ink: Oil-based pen that dries fast and produces dark, shiny lines.

FORAY Stylemark 0.5 mm: Quick-drying pen that resists smearing. Great for lefties!

Pilot V CORN: Liquid ink rollerball pen with cone-shaped tip.

Copic Multiliner SP 0.25: Produces a thin line perfect for small details.

Itoya Paper Skater: Super smooth ink flow makes drawing easy.

Uni Jetstream Standard: Offers a flexible, smooth feel.

Pilot Hi-Tec-C: Gel pen with a comfortable grip.

Markers

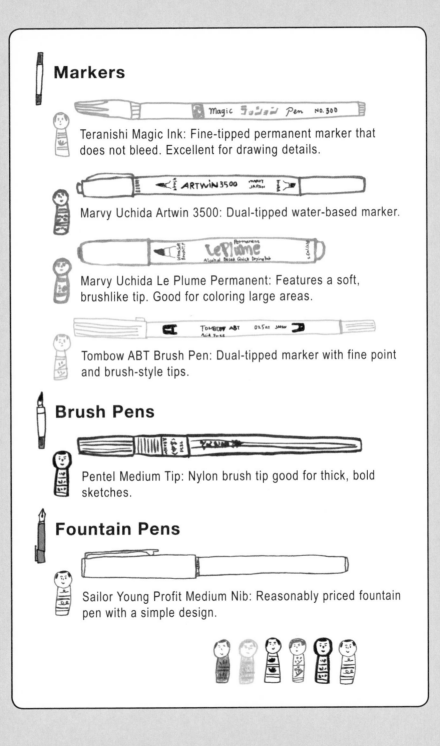

Teranishi Magic Ink: Fine-tipped permanent marker that does not bleed. Excellent for drawing details.

Marvy Uchida Artwin 3500: Dual-tipped water-based marker.

Marvy Uchida Le Plume Permanent: Features a soft, brushlike tip. Good for coloring large areas.

Tombow ABT Brush Pen: Dual-tipped marker with fine point and brush-style tips.

Brush Pens

Pentel Medium Tip: Nylon brush tip good for thick, bold sketches.

Fountain Pens

Sailor Young Profit Medium Nib: Reasonably priced fountain pen with a simple design.

Warm Up: Practice Drawing Lines

Draw different styles of lines, such as squiggly lines, wavy lines, and jagged lines. Use lines to express movement or mood within your drawings.

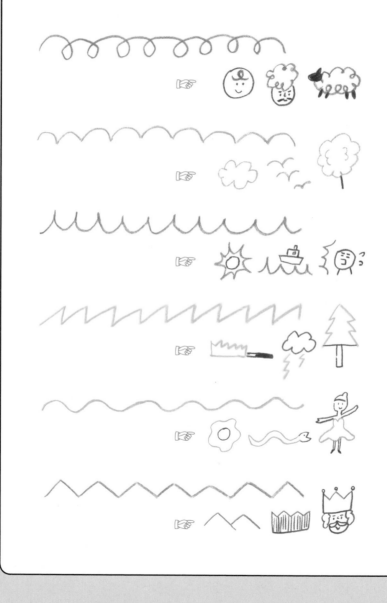

Warm Up: Practice Drawing Shapes

Most illustrations start out with a basic shape, such as a circle, triangle, or square. Add lines and other details to transform a basic shape into a finished object.

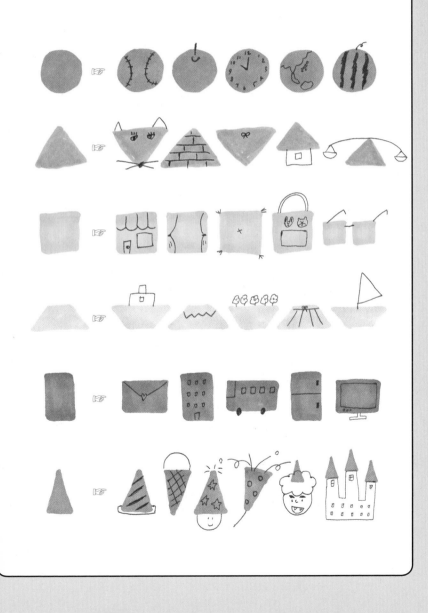

How to Use This Book

The Drawing Process

Most of the entries in this book include step-by-step illustrations that show the drawing process from start to finish. Some of the more advanced entries, or those which are variations of other entries, are not broken down into individual steps. Simply trace the image to practice drawing these entries.

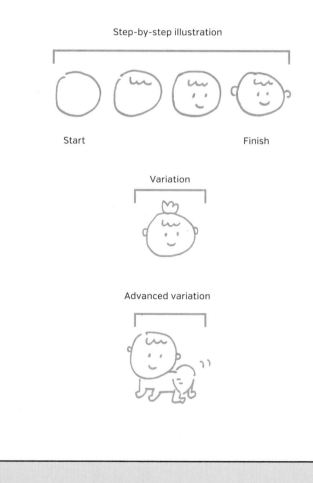

Step-by-step illustration

Start Finish

Variation

Advanced variation

Animals

 Terrestrial Animals

Aquatic Animals & Fish

 Birds

Bugs & Insects

 Dinosaurs

Unidentified Mysterious Animals

Terrestrial Animals

Adding details like fur texture and pattern will help make your animal drawings more realistic.

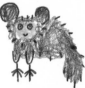

aye-aye

raccoon

anteater

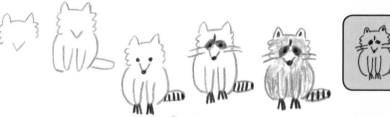

alpaca

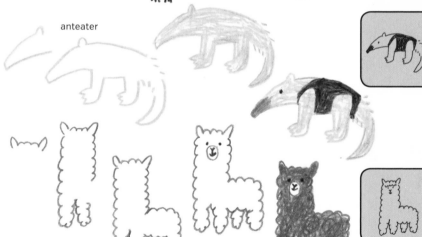

armadillo

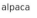

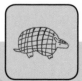

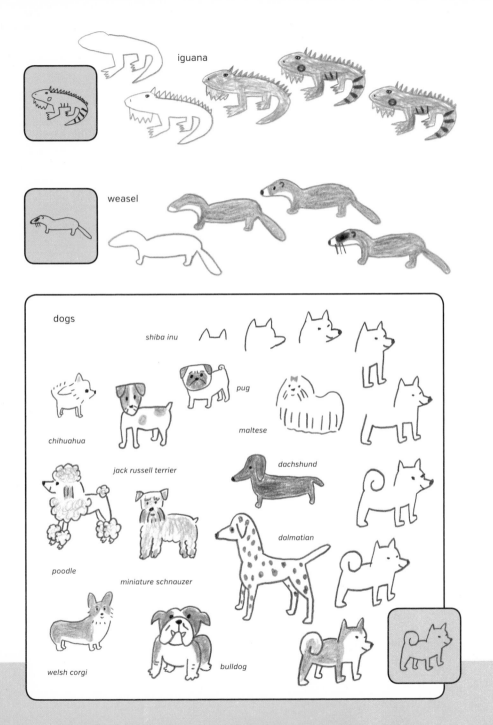

iguana

weasel

dogs

shiba inu

chihuahua

pug

maltese

jack russell terrier

dachshund

poodle

miniature schnauzer

dalmatian

welsh corgi

bulldog

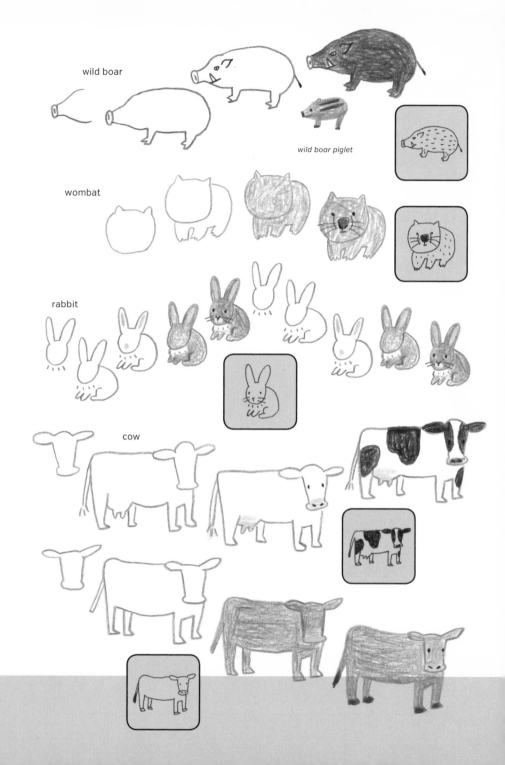

wild boar

wild boar piglet

wombat

rabbit

cow

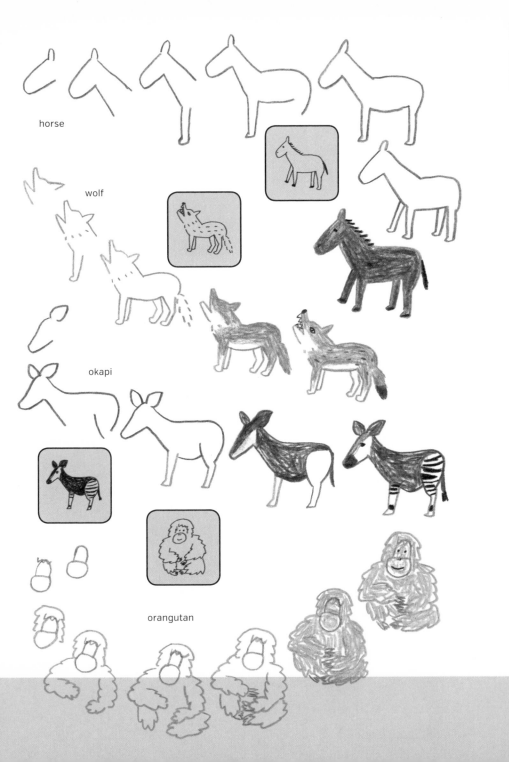

horse

wolf

okapi

orangutan

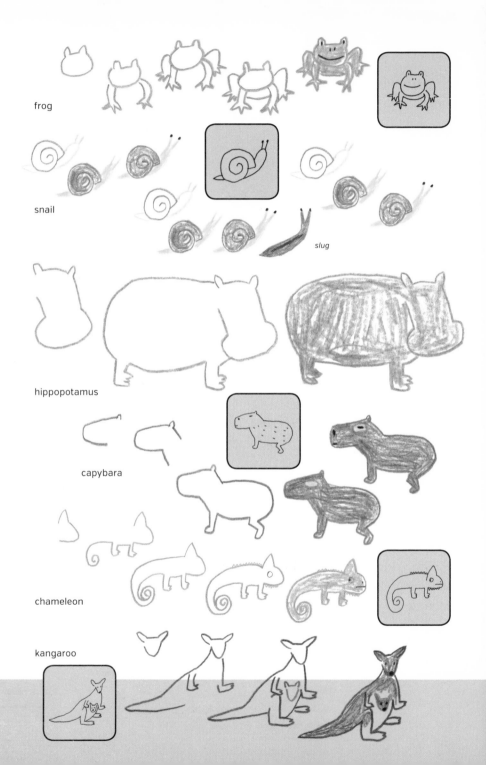

frog

snail

slug

hippopotamus

capybara

chameleon

kangaroo

fox

giraffe

bear

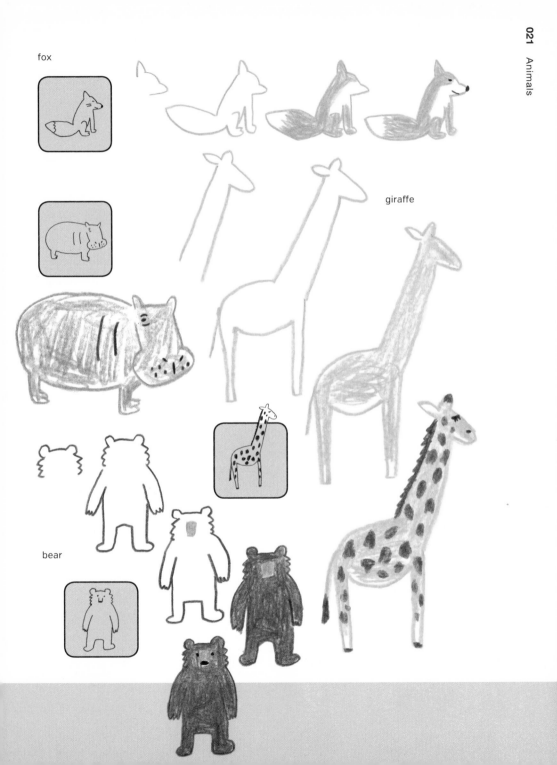

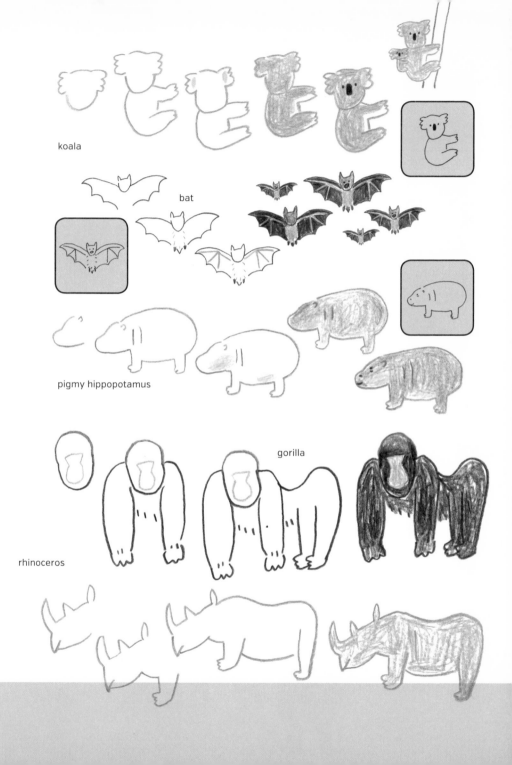

koala

bat

pigmy hippopotamus

gorilla

rhinoceros

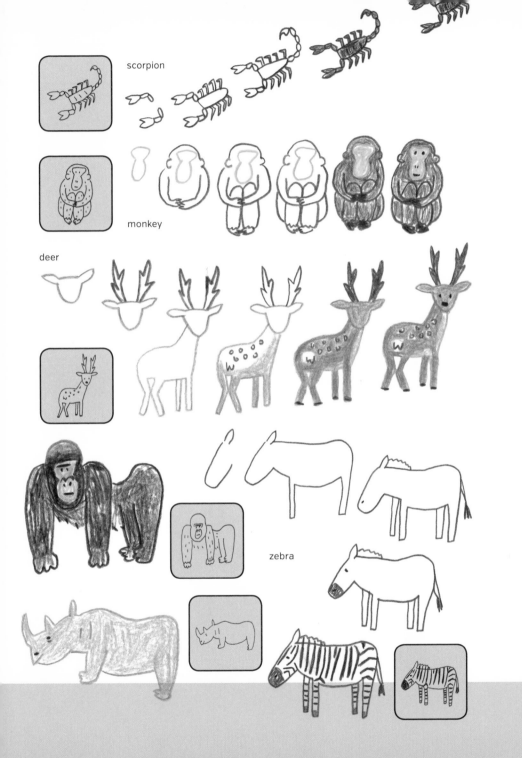

scorpion

monkey

deer

zebra

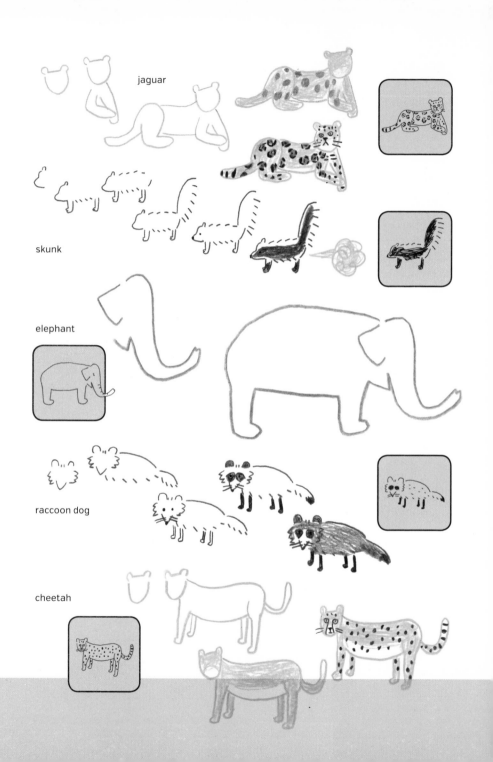

jaguar

skunk

elephant

raccoon dog

cheetah

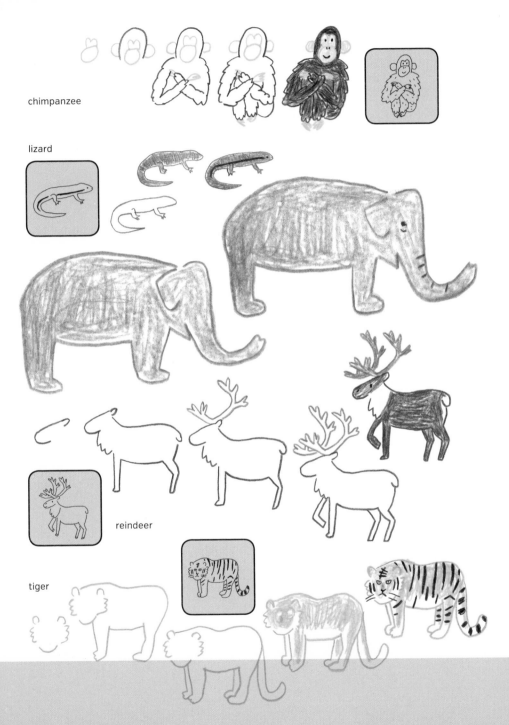

chimpanzee

lizard

reindeer

tiger

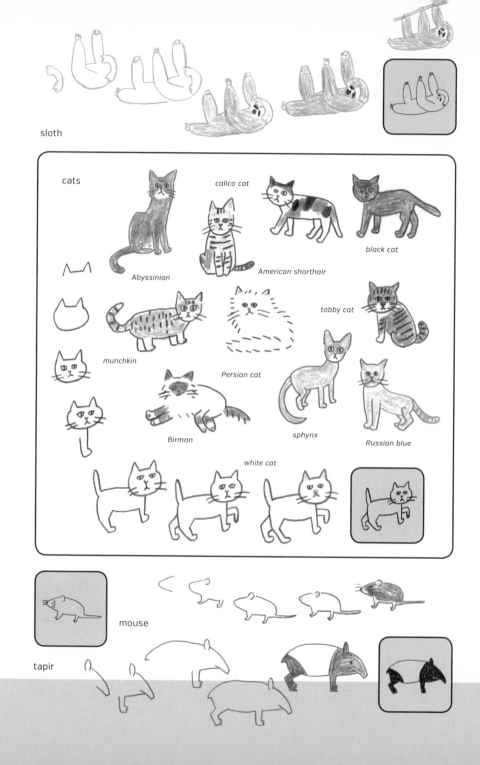

sloth

cats

calico cat

black cat

Abyssinian

American shorthair

tabby cat

munchkin

Persian cat

Birman

sphynx

Russian blue

white cat

mouse

tapir

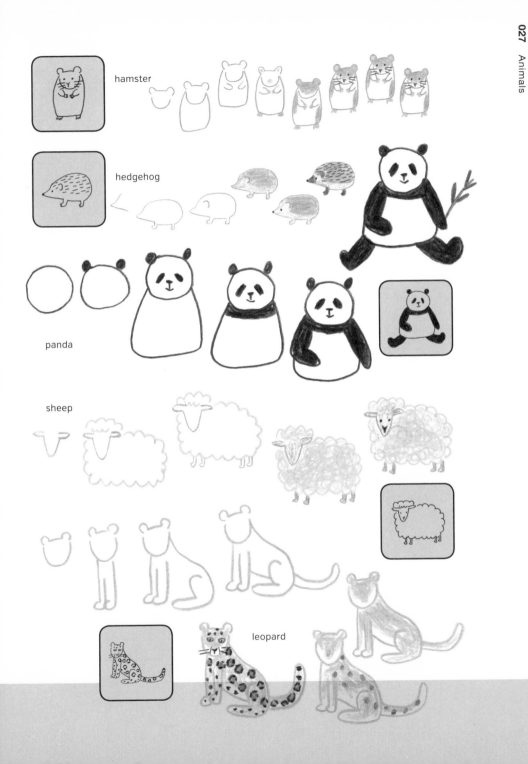

hamster

hedgehog

panda

sheep

leopard

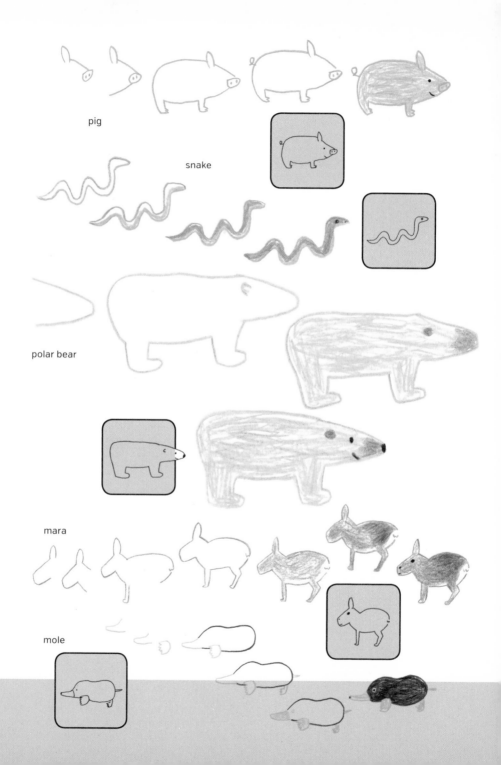

pig

snake

polar bear

mara

mole

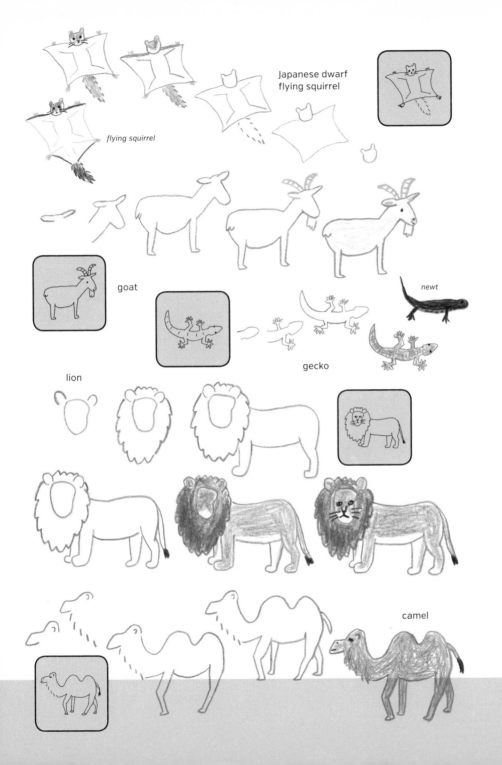

Japanese dwarf
flying squirrel

flying squirrel

goat

newt

gecko

lion

camel

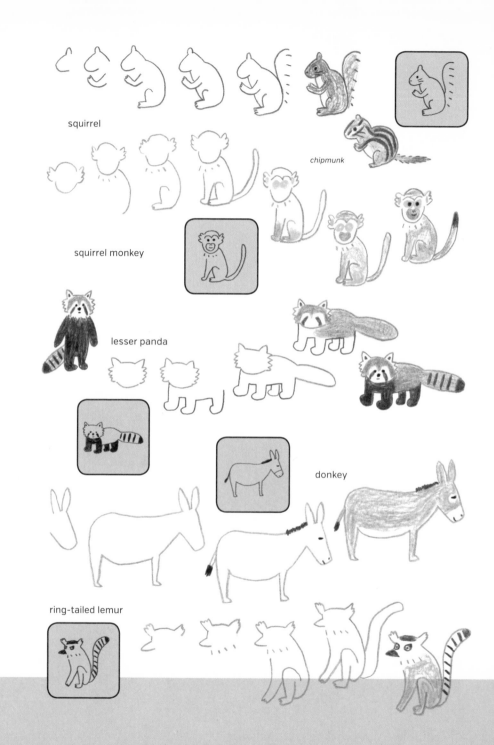

squirrel

chipmunk

squirrel monkey

lesser panda

donkey

ring-tailed lemur

Aquatic Animals & Fish

Use a felt-tipped pen to lend your drawings an underwater impression.

seal

sea lion

sweetfish

angler

squid

sea anemone

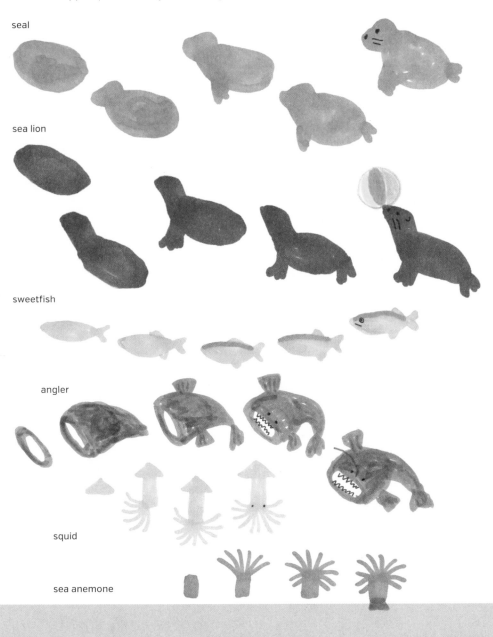

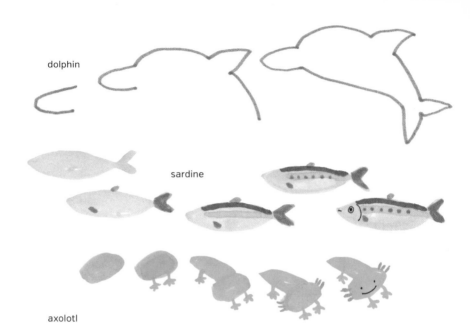

dolphin

sardine

axolotl

moray eel

eel

sea urchin

sea snake

sea slug

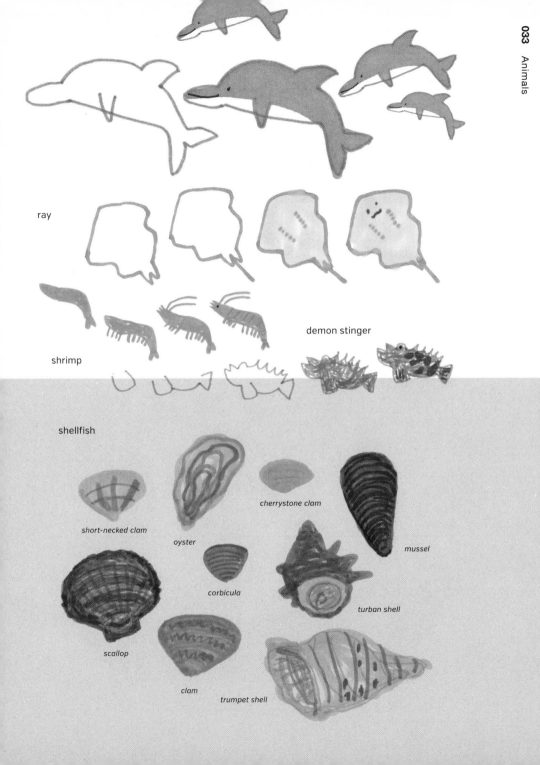

ray

shrimp

demon stinger

shellfish

short-necked clam

oyster

cherrystone clam

mussel

corbicula

turban shell

scallop

clam

trumpet shell

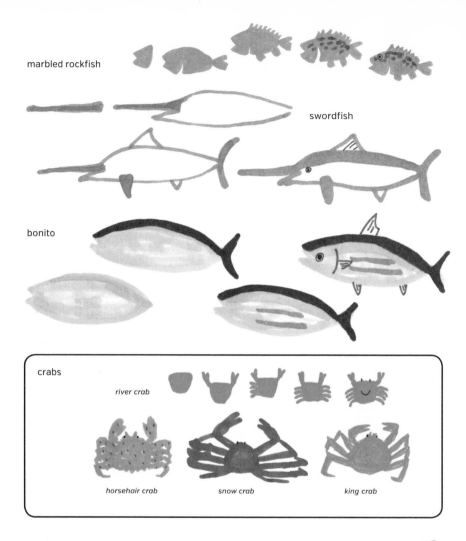

marbled rockfish

swordfish

bonito

crabs

river crab

horsehair crab snow crab king crab

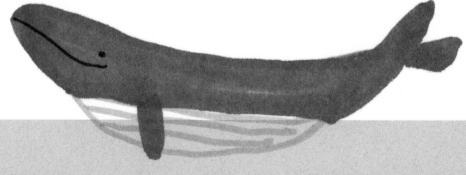

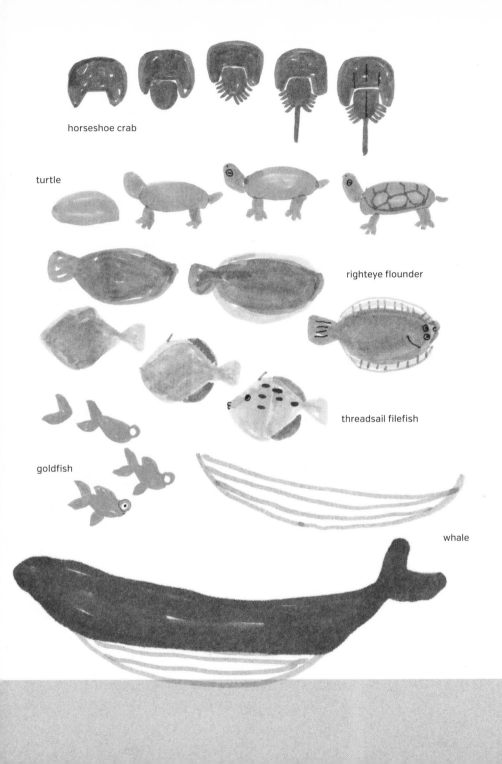

horseshoe crab

turtle

righteye flounder

threadsail filefish

goldfish

whale

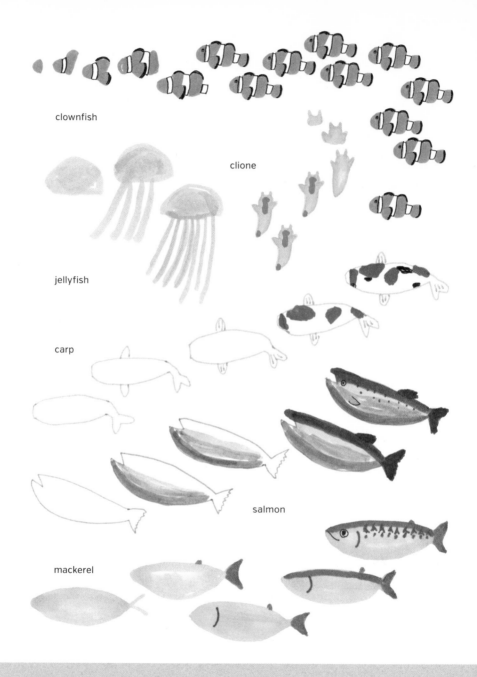

clownfish

clione

jellyfish

carp

salmon

mackerel

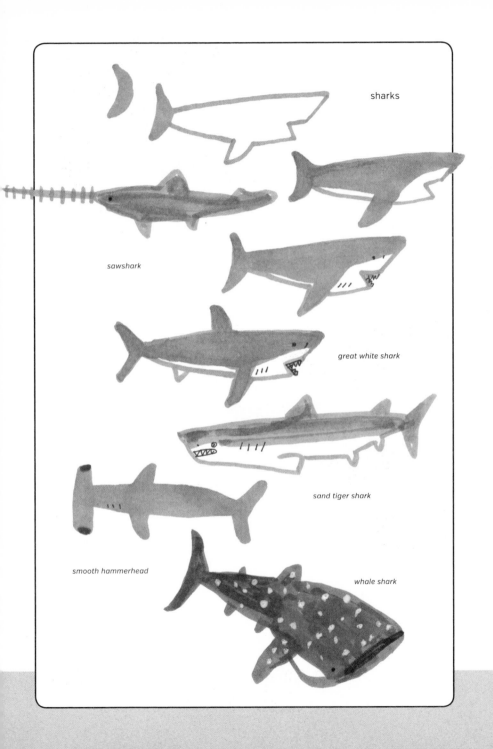

sharks

sawshark

great white shark

sand tiger shark

smooth hammerhead

whale shark

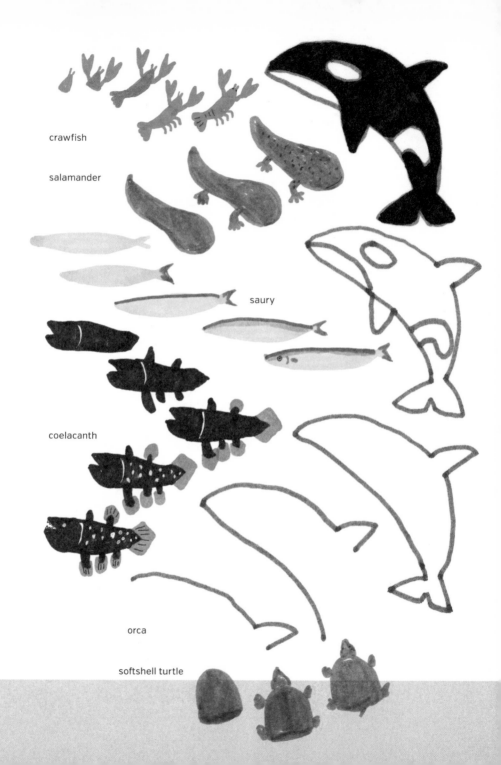

crawfish

salamander

saury

coelacanth

orca

softshell turtle

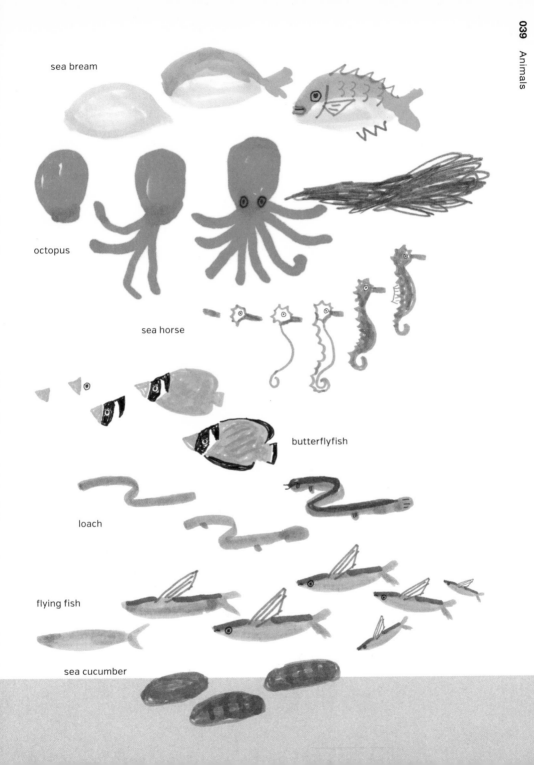

sea bream

octopus

sea horse

butterflyfish

loach

flying fish

sea cucumber

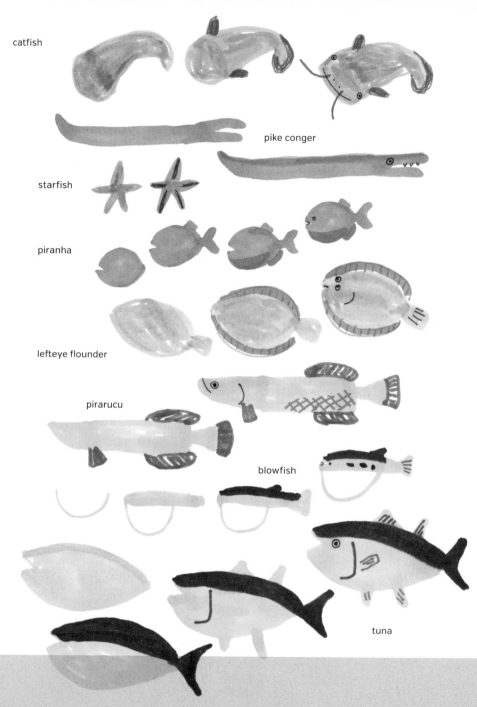

catfish

pike conger

starfish

piranha

lefteye flounder

pirarucu

blowfish

tuna

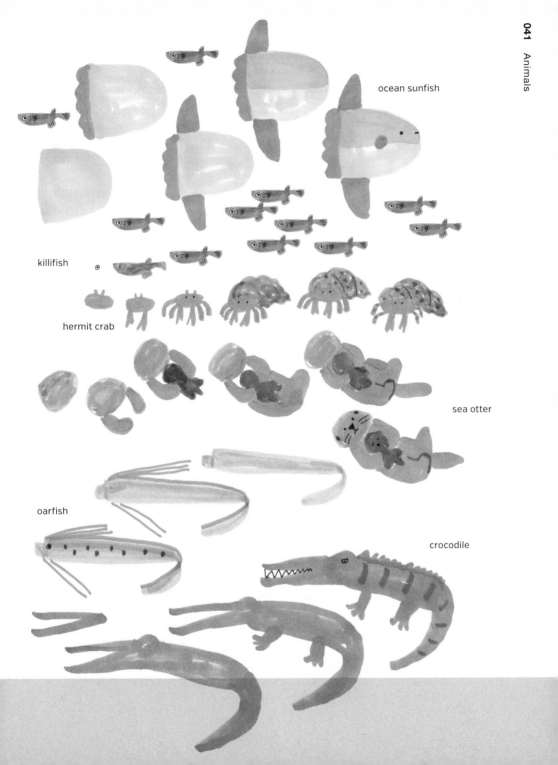

ocean sunfish

killifish

hermit crab

sea otter

oarfish

crocodile

Birds

Details such as feather pattern and length and thickness of the legs will help make your bird drawings more accurate.

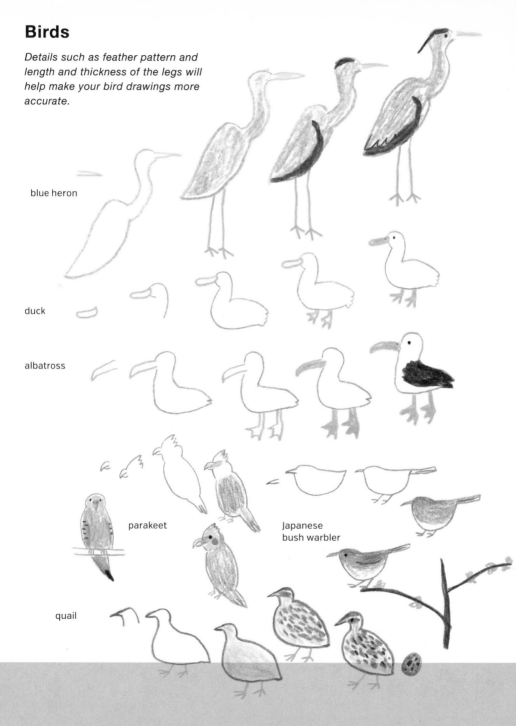

blue heron

duck

albatross

parakeet

Japanese bush warbler

quail

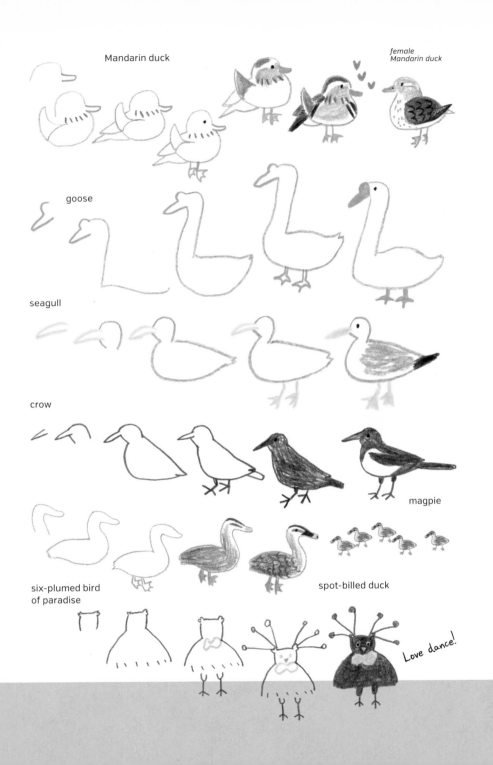

Mandarin duck

female Mandarin duck

goose

seagull

crow

magpie

six-plumed bird of paradise

spot-billed duck

Love dance!

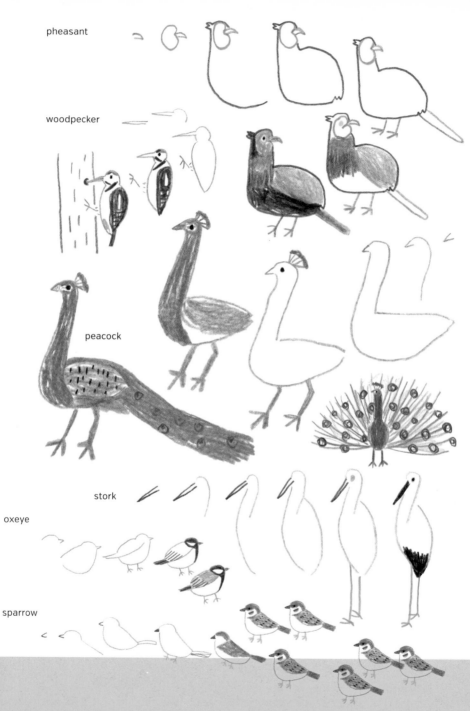

pheasant

woodpecker

peacock

stork

oxeye

sparrow

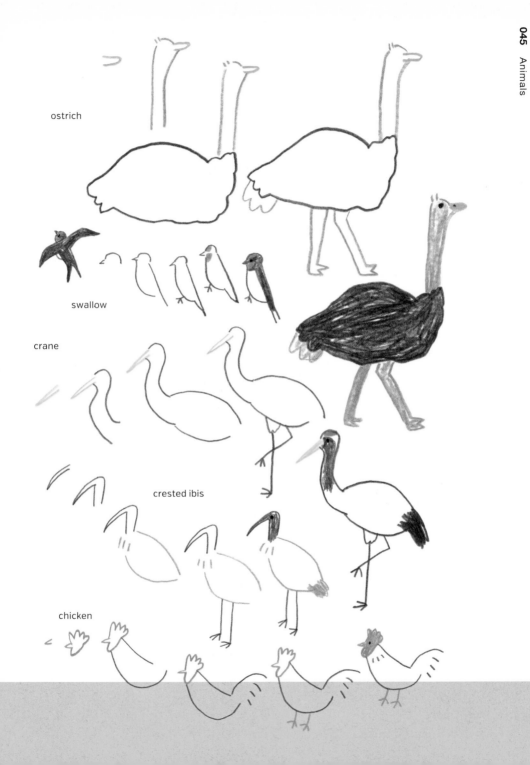

ostrich

swallow

crane

crested ibis

chicken

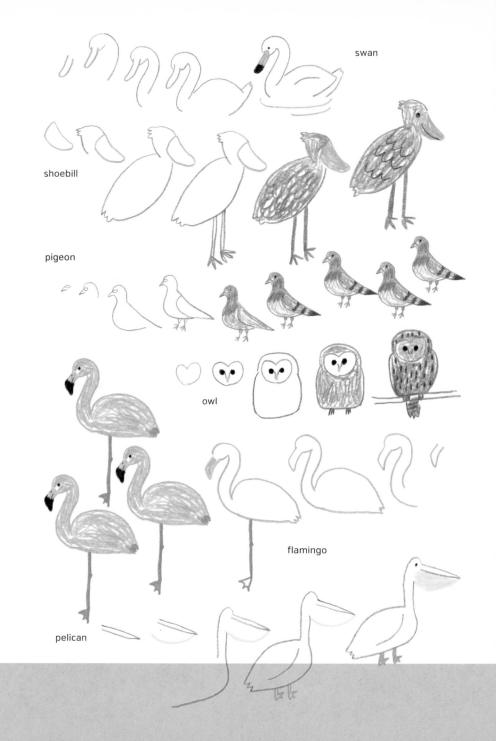

swan

shoebill

pigeon

owl

flamingo

pelican

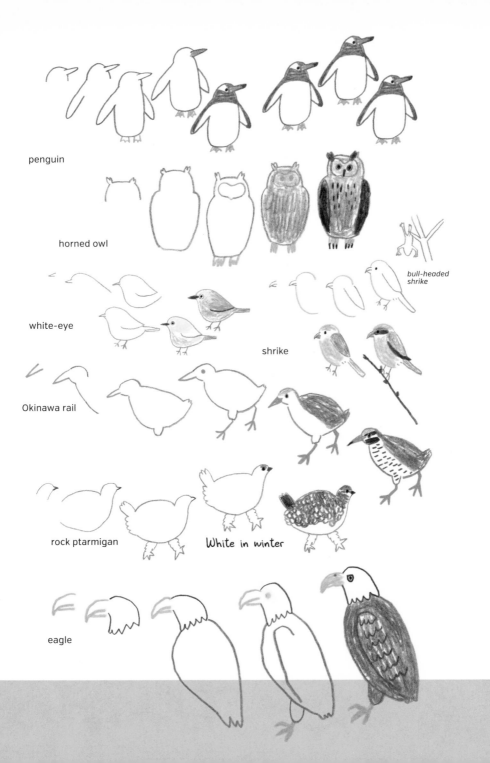

penguin

horned owl

bull-headed shrike

white-eye

shrike

Okinawa rail

rock ptarmigan

White in winter

eagle

Bugs & Insects

Details such as the shape of the head and the length of the antennae will help differentiate between similar insects.

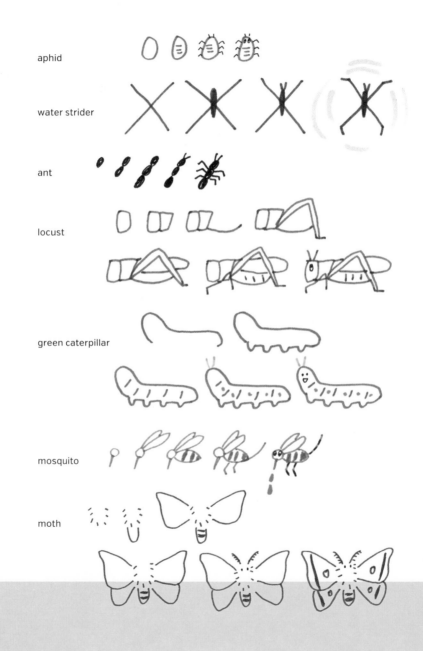

aphid

water strider

ant

locust

green caterpillar

mosquito

moth

scarab beetle

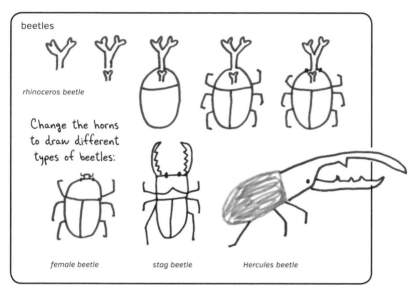

beetles

rhinoceros beetle

Change the horns to draw different types of beetles:

female beetle *stag beetle* *Hercules beetle*

mantis

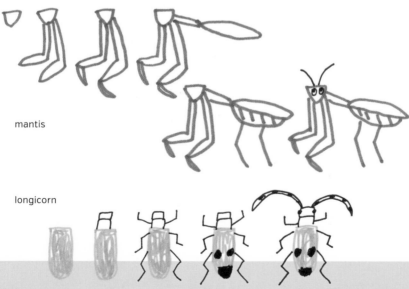

longicorn

stink bug

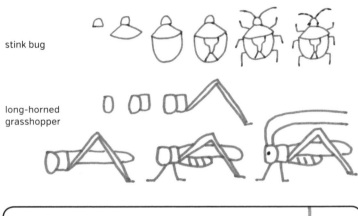

long-horned
grasshopper

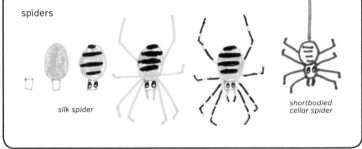

spiders

silk spider

*shortbodied
cellar spider*

hairy caterpillar

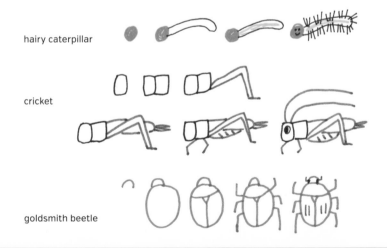

cricket

goldsmith beetle

cockroach

Oriental long-headed locust

bell
cricket

skipper

cicada

tarantula

pill bug

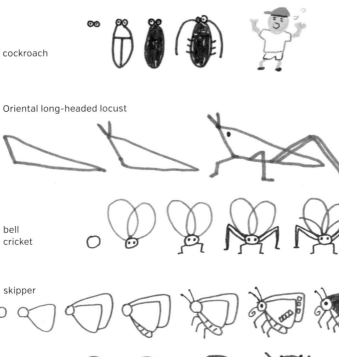
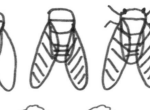

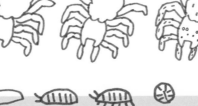

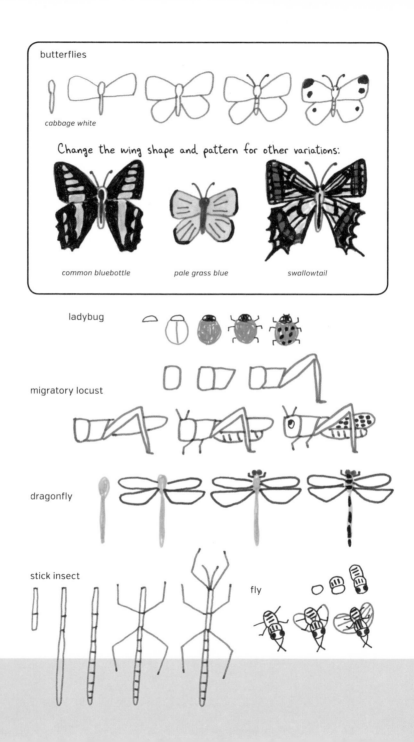

butterflies

cabbage white

Change the wing shape and pattern for other variations:

common bluebottle pale grass blue swallowtail

ladybug

migratory locust

dragonfly

stick insect

fly

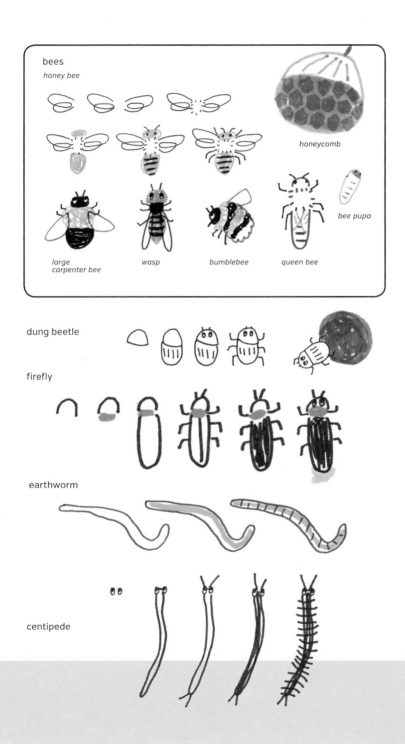

bees

honey bee

honeycomb

bee pupa

large carpenter bee

wasp

bumblebee

queen bee

dung beetle

firefly

earthworm

centipede

Dinosaurs

To recreate these dinosaur illustrations, draw bold outlines, then have fun adding color.

archaeopteryx

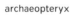

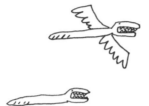

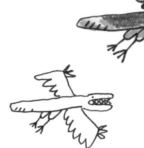

argentinosaurus

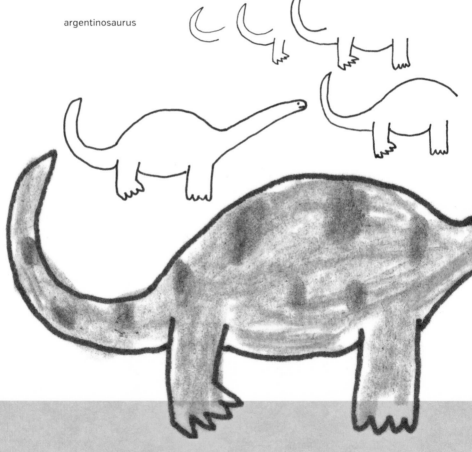

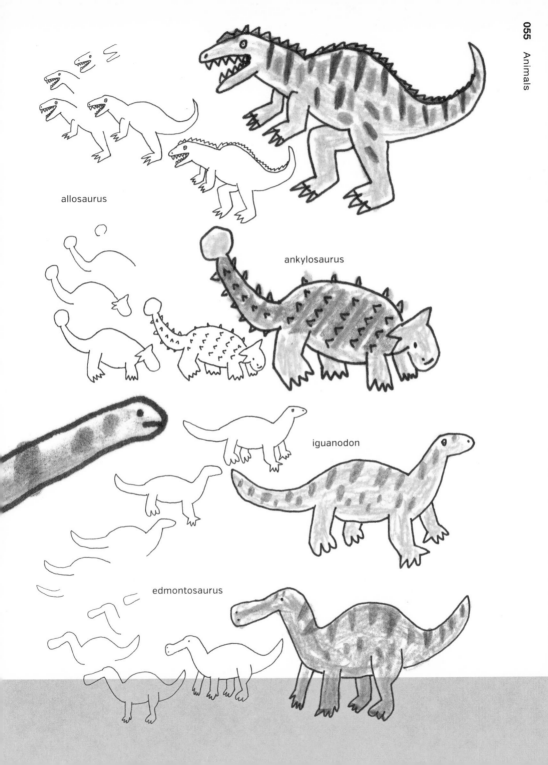

allosaurus

ankylosaurus

iguanodon

edmontosaurus

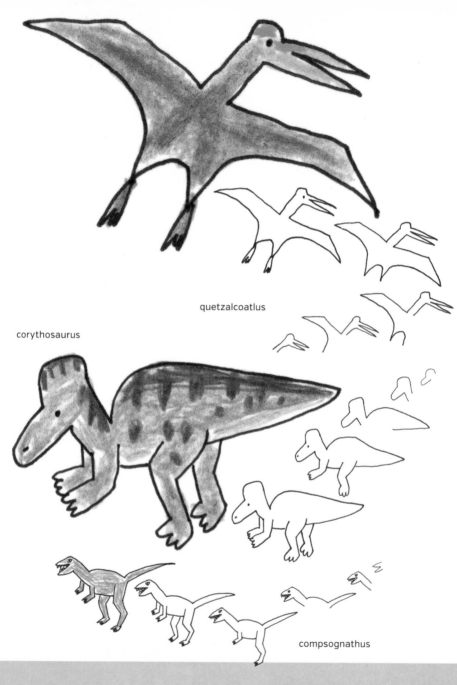

quetzalcoatlus

corythosaurus

compsognathus

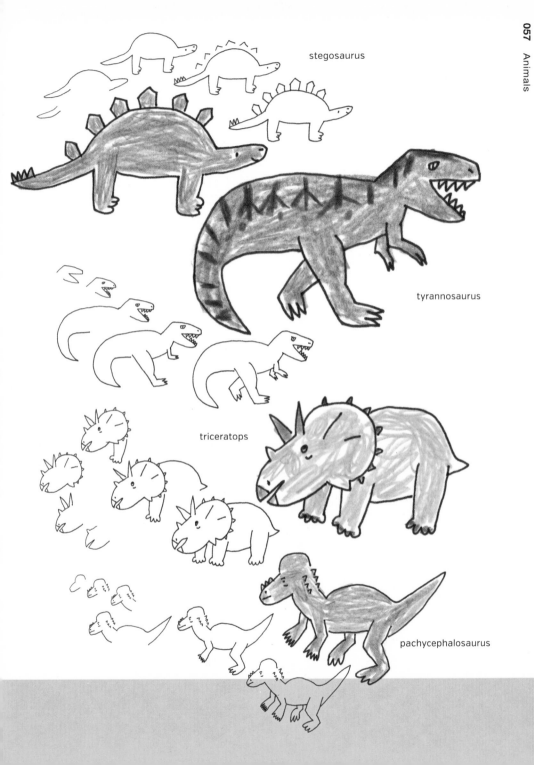

stegosaurus

tyrannosaurus

triceratops

pachycephalosaurus

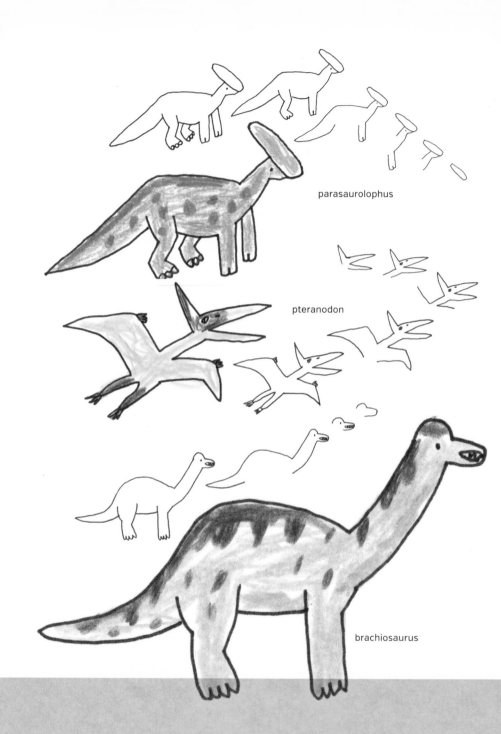

parasaurolophus

pteranodon

brachiosaurus

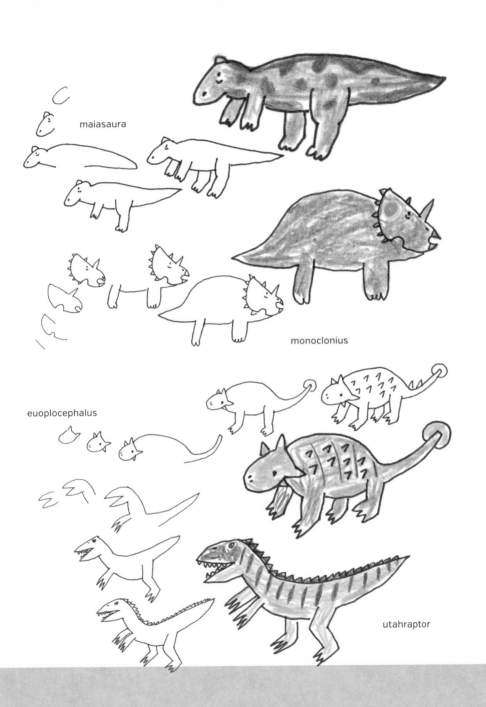

maiasaura

monoclonius

euoplocephalus

utahraptor

CHALLENGE #1:
Draw a Zoo

Once you've perfected drawing animals, put your new skills to work by drawing a zoo scene. This challenge will provide you with an opportunity to practice drawing animals in action as they sleep, eat, and climb. Use a variety of art supplies for the different components of the drawing, including the animals, fences, and landscape, to create a 3-D look.

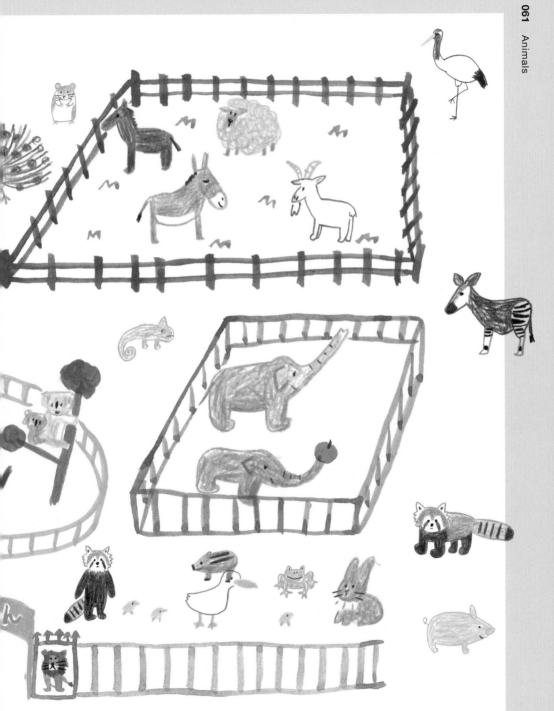

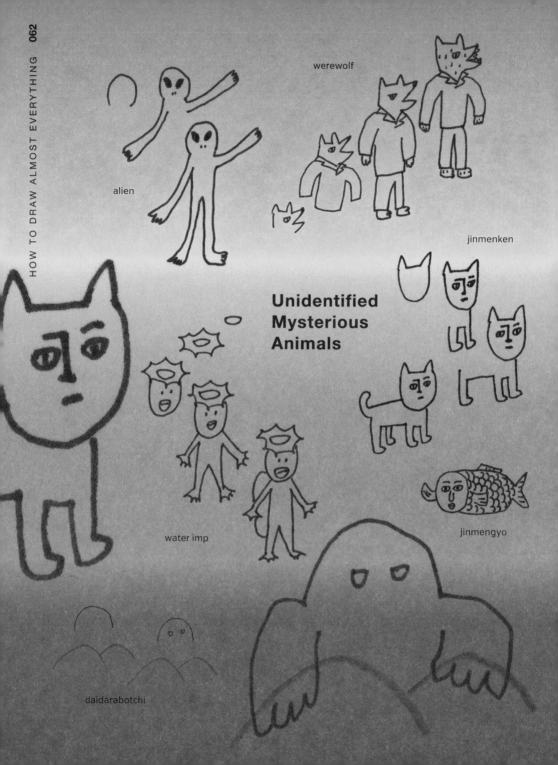

werewolf

alien

jinmenken

**Unidentified
Mysterious
Animals**

water imp

jinmengyo

daidarabotchi

tsuchinoko

long-nosed goblin

Dracula

mermaid

Loch Ness monster

Frankenstein

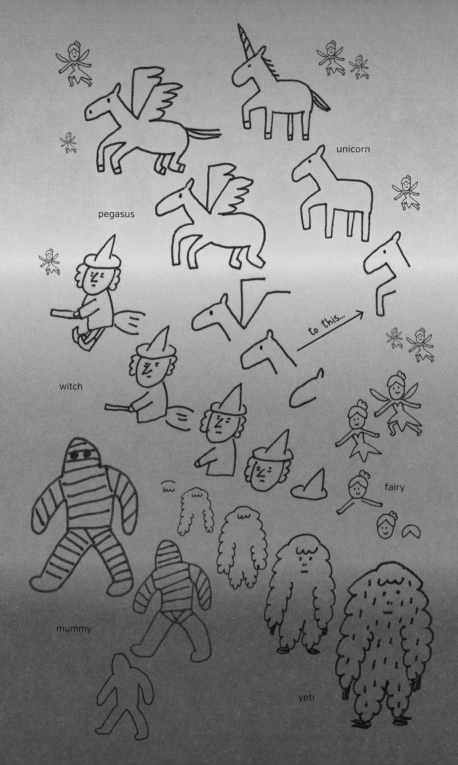

unicorn

pegasus

witch

to this...

fairy

mummy

yeti

People

 Faces

 Expressions

 Actions

 People by Age & Gender

 Clothing

Occupations

Famous Faces

Faces

Just changing one component of the face will give a person a completely different look.

Use simple lines

the parts of face

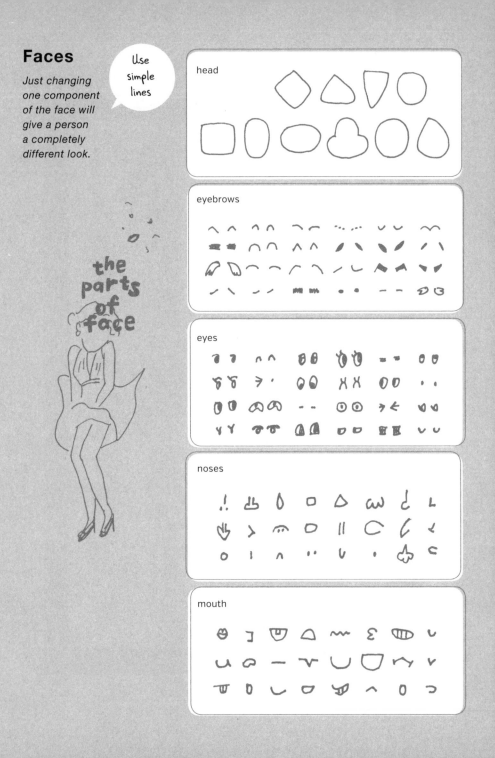

head

eyebrows

eyes

noses

mouth

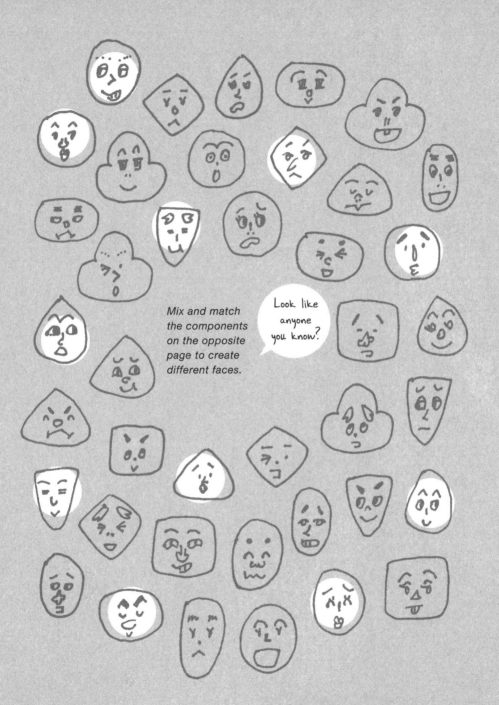

Mix and match the components on the opposite page to create different faces.

Look like anyone you know?

Expressions

You can draw so many different emotions using just a few quick lines.

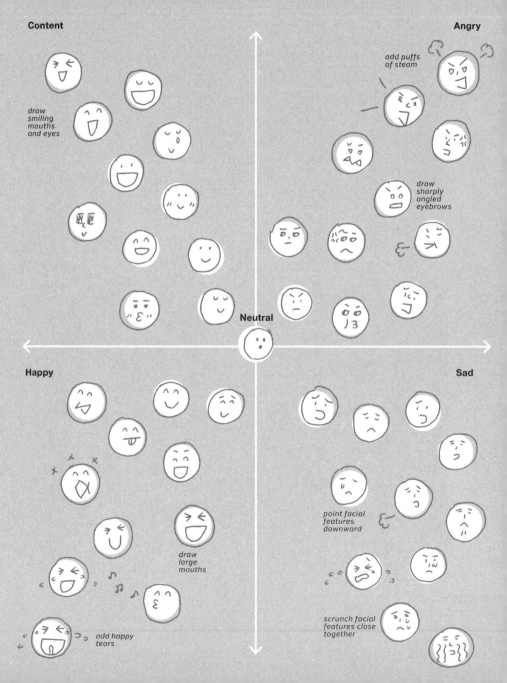

Actions

Add arms and legs to illustrate various movements.

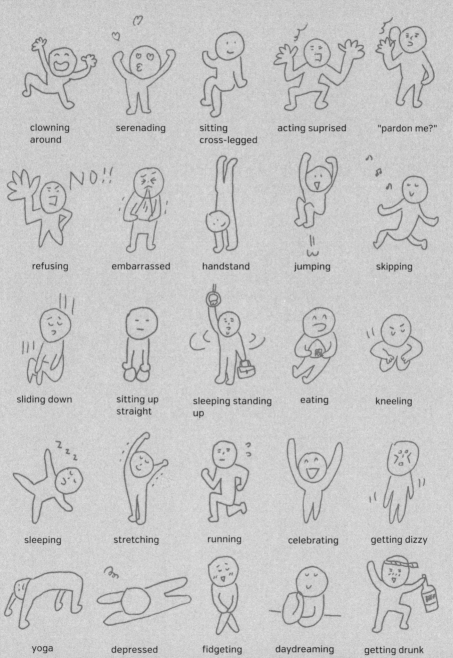

clowning around

serenading

sitting cross-legged

acting suprised

"pardon me?"

refusing

embarrassed

handstand

jumping

skipping

sliding down

sitting up straight

sleeping standing up

eating

kneeling

sleeping

stretching

running

celebrating

getting dizzy

yoga

depressed

fidgeting

daydreaming

getting drunk

People by Age and Gender: Babies

When drawing a baby, make both the head and body rounded. Add extra hair and ribbon for a baby girl.

head

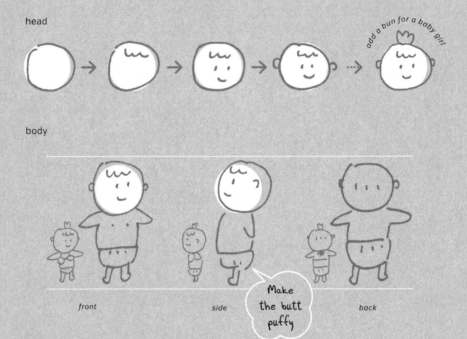

body

front side back

Make the butt puffy

add a bun for a baby girl

hair

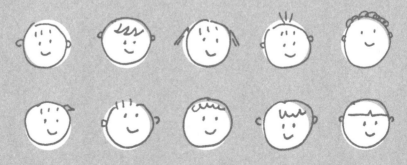

Babies

People by Age and Gender: Boys

As boys grow up, their faces change from round to oval.
You can also indicate age by changing the proportion of
the head and body.

head

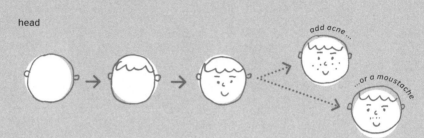

add acne...

...or a moustache

body

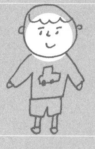

front *side* *back*

hair

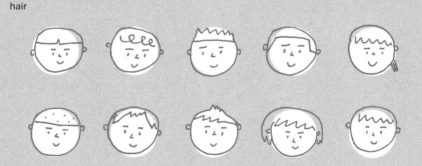

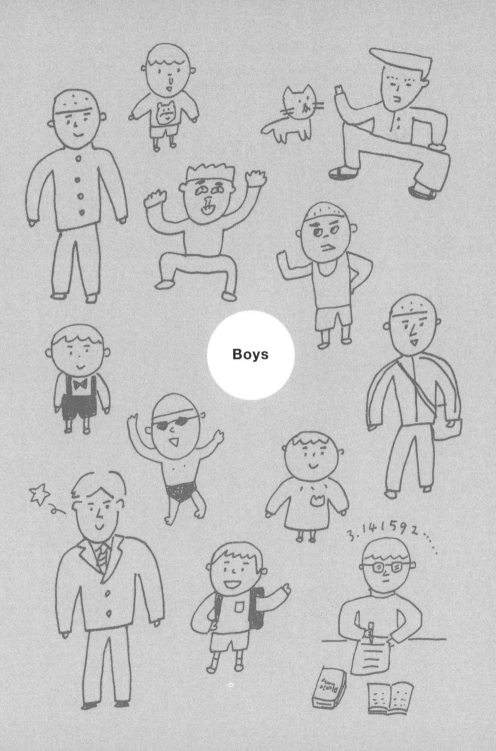

Boys

3.141592...

People by Age and Gender: Girls

Express a girl's individuality by changing her hairstyle or her clothes. Just like when drawing boys, adjust the proportion of the head and body to indicate age.

head

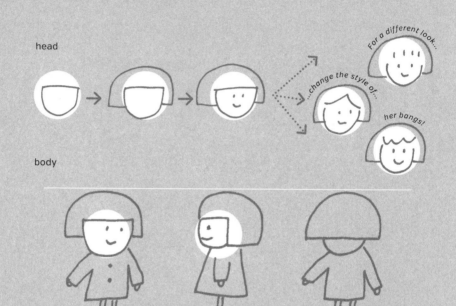

For a different look...

...change the style of...

her bangs!

body

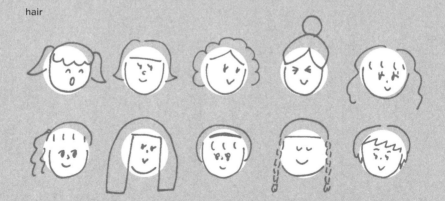

front side back

hair

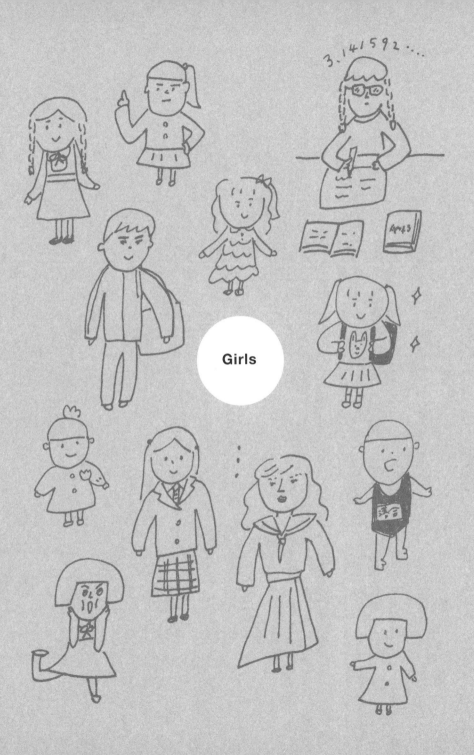

Girls

People by Age and Gender: Men

Consider body type—draw wide shoulders for an athletic body or narrow shoulders for a slim body.

head

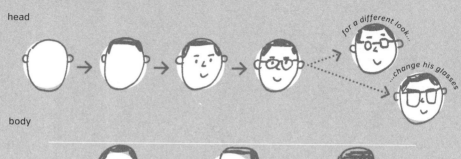

body

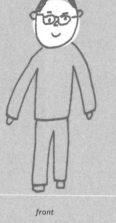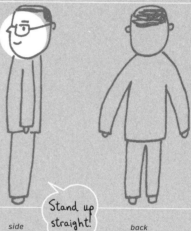

front *side* *back*

Stand up straight!

hair

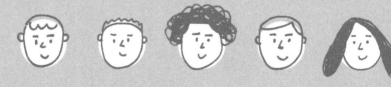

facial hair

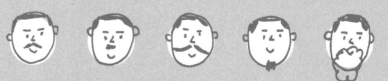

Men

People by Age and Gender: Women

Create different impressions by altering a woman's hairstyle, eyelashes, and eyebrows.

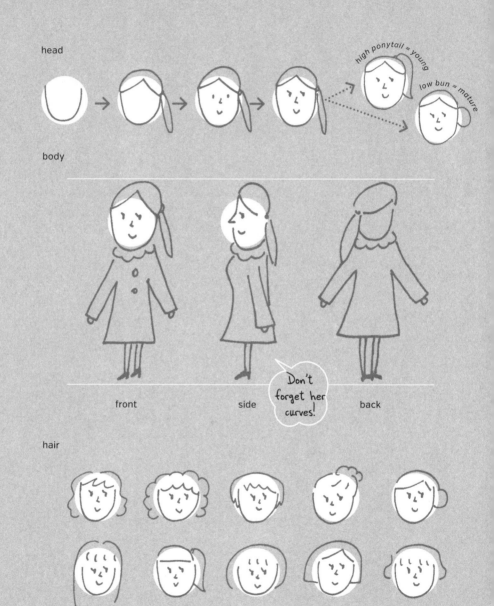

head

high ponytail = young

low bun = mature

body

front

side

Don't forget her curves!

back

hair

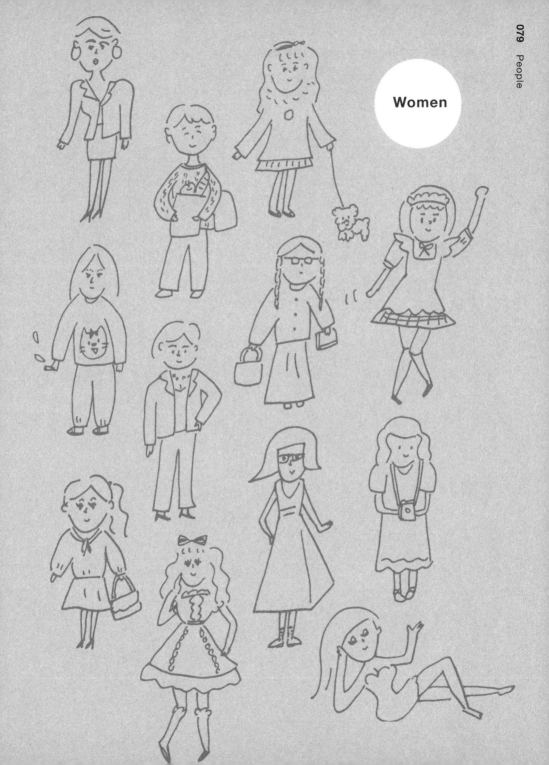

Women

People by Age and Gender: Elderly Men

Use laugh lines, crows feet, and bushy eyebrows to express age within the face. When drawing an elderly man's body, consider his posture and include details such as hunched shoulders.

head

young middle-aged elderly

body

front side back

hair

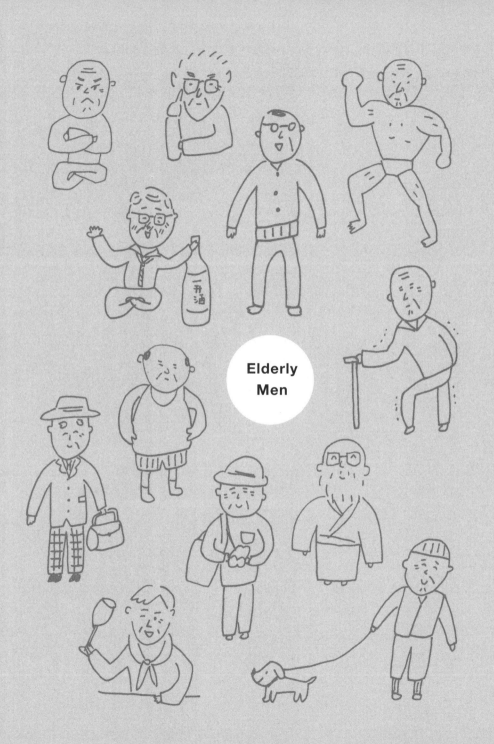

Elderly
Men

People by Age and Gender: Elderly Women

Older women often wear their hair short or pulled back in a low bun. Don't forget to add deep laugh lines around her mouth.

head

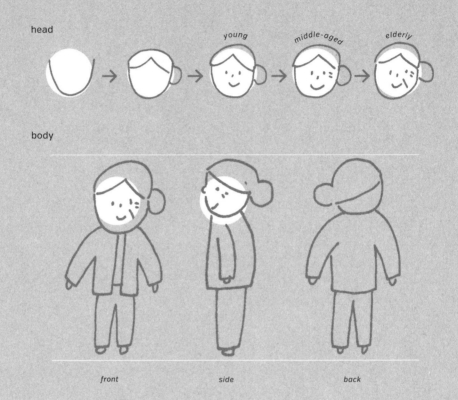

body

front side back

hair

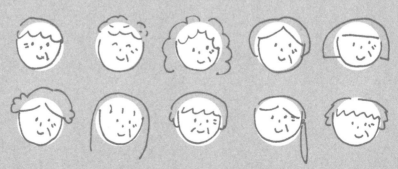

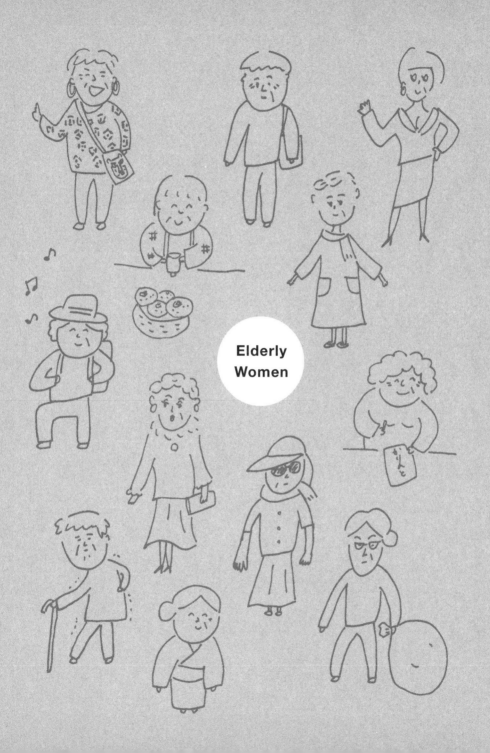

Elderly
Women

Clothing

Clothing provides an excellent opportunity to include details about a person's age, gender, and personality.

fur coat

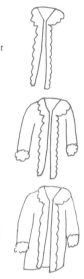

outerwear

collarless jacket

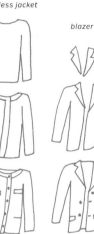

blazer

letterman jacket

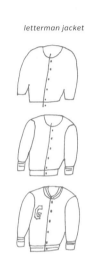

leather coat

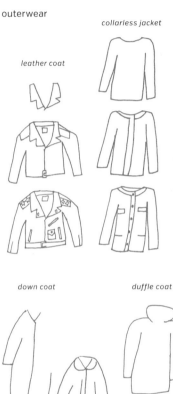

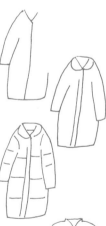

down coat

duffle coat

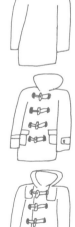

trench coat

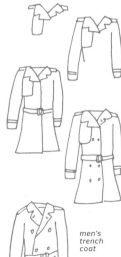

pea coat

down jacket

men's trench coat

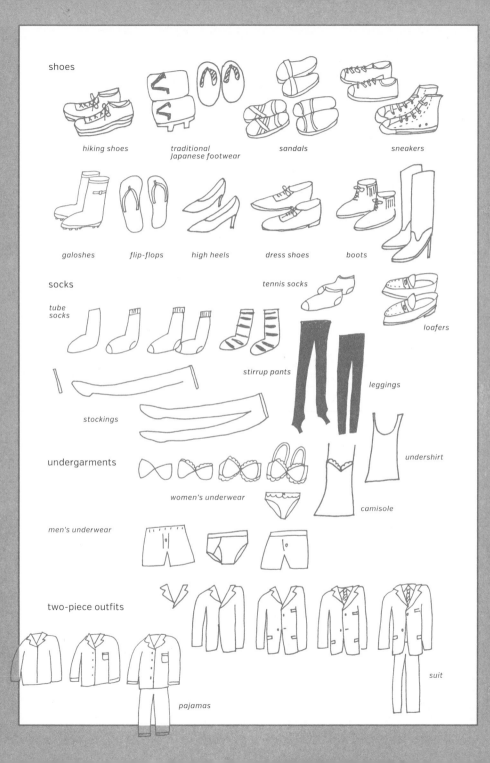

shoes

hiking shoes

traditional Japanese footwear

sandals

sneakers

galoshes

flip-flops

high heels

dress shoes

boots

socks

tennis socks

loafers

tube socks

stirrup pants

leggings

stockings

undergarments

undershirt

women's underwear

camisole

men's underwear

two-piece outfits

suit

pajamas

tops

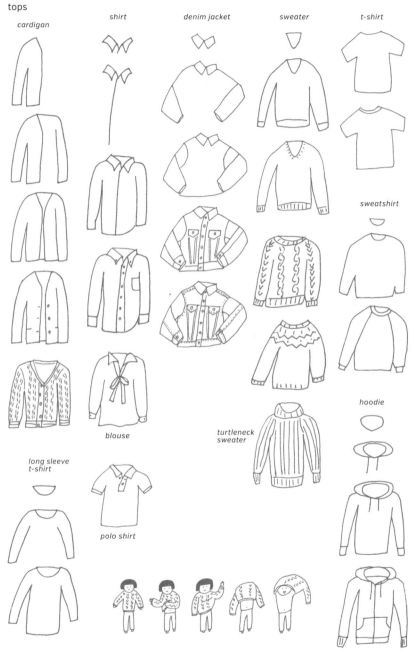

cardigan

shirt

denim jacket

sweater

t-shirt

sweatshirt

blouse

turtleneck
sweater

hoodie

long sleeve
t-shirt

polo shirt

bottoms

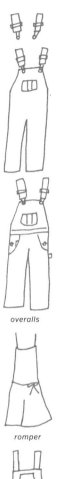

overalls

romper

coveralls

jeans

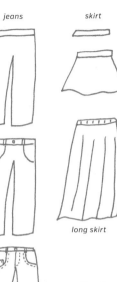

cutoffs

skirt

long skirt

skinny jeans

chinos

bell-bottoms

dress

newscaster

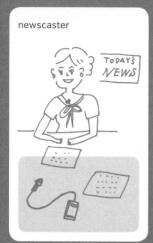

medical doctor

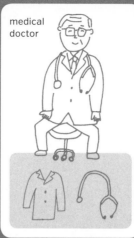

sushi chef

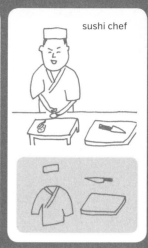

artist

Remember to add detail!

Occupations

For realistic looking drawings, add detailed outfits and props related to the occupation.

astronaut

film director

business-woman

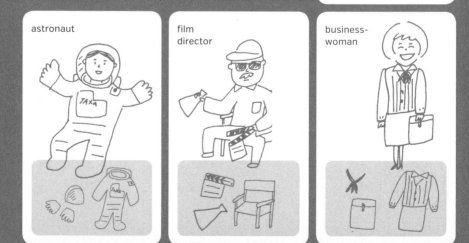

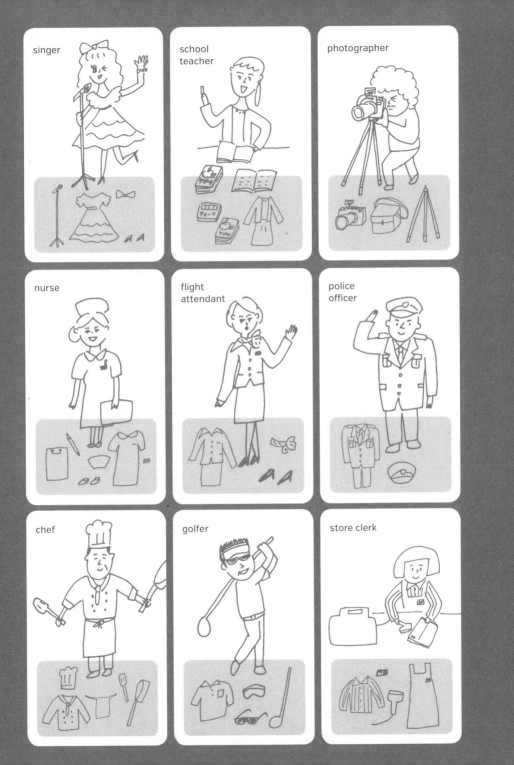

singer

school teacher

photographer

nurse

flight attendant

police officer

chef

golfer

store clerk

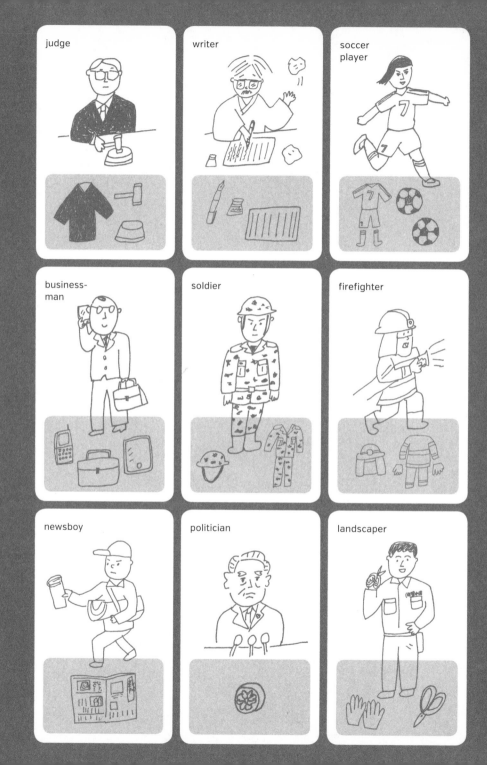

judge

writer

soccer player

business-man

soldier

firefighter

newsboy

politician

landscaper

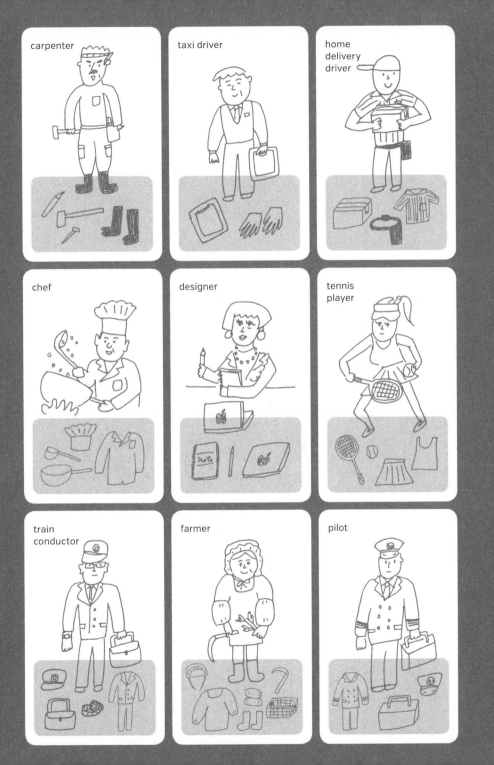

carpenter

taxi driver

home delivery driver

chef

designer

tennis player

train conductor

farmer

pilot

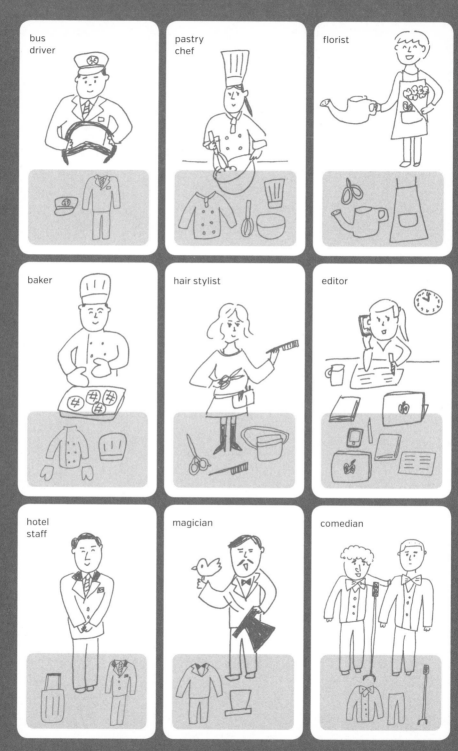

bus driver

pastry chef

florist

baker

hair stylist

editor

hotel staff

magician

comedian

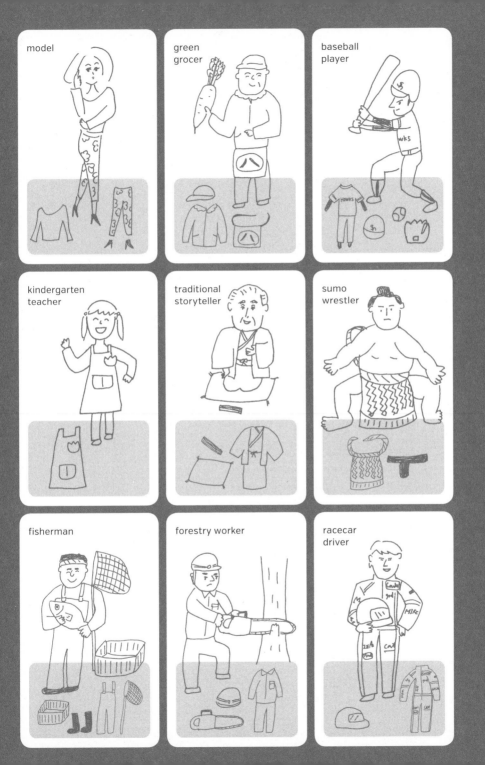

model

green grocer

baseball player

kindergarten teacher

traditional storyteller

sumo wrestler

fisherman

forestry worker

racecar driver

Famous Faces

Capture the most memorable characteristics by concentrating on the hairstyles, expressions, and outfits worn by these famous figures in history.

Musicians

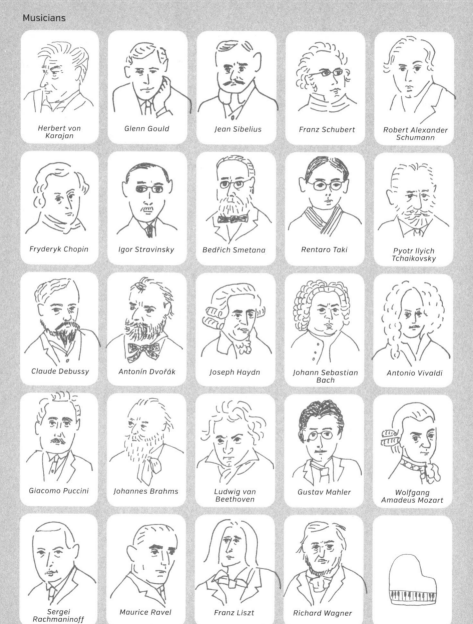

Herbert von Karajan Glenn Gould Jean Sibelius Franz Schubert Robert Alexander Schumann

Fryderyk Chopin Igor Stravinsky Bedřich Smetana Rentaro Taki Pyotr Ilyich Tchaikovsky

Claude Debussy Antonín Dvořák Joseph Haydn Johann Sebastian Bach Antonio Vivaldi

Giacomo Puccini Johannes Brahms Ludwig van Beethoven Gustav Mahler Wolfgang Amadeus Mozart

Sergei Rachmaninoff Maurice Ravel Franz Liszt Richard Wagner

Artists

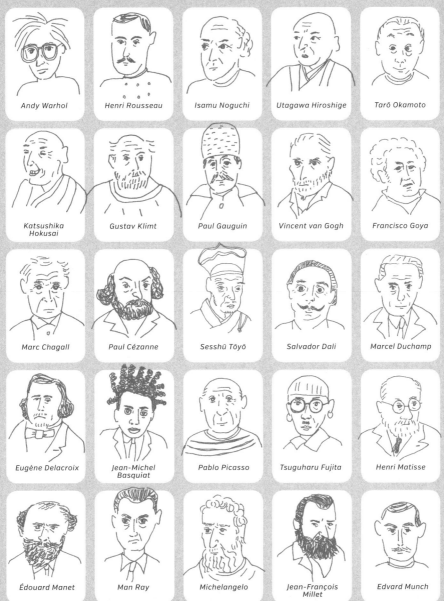

Andy Warhol

Henri Rousseau

Isamu Noguchi

Utagawa Hiroshige

Tarō Okamoto

Katsushika Hokusai

Gustav Klimt

Paul Gauguin

Vincent van Gogh

Francisco Goya

Marc Chagall

Paul Cézanne

Sesshū Tōyō

Salvador Dali

Marcel Duchamp

Eugène Delacroix

Jean-Michel Basquiat

Pablo Picasso

Tsuguharu Fujita

Henri Matisse

Édouard Manet

Man Ray

Michelangelo

Jean-François Millet

Edvard Munch

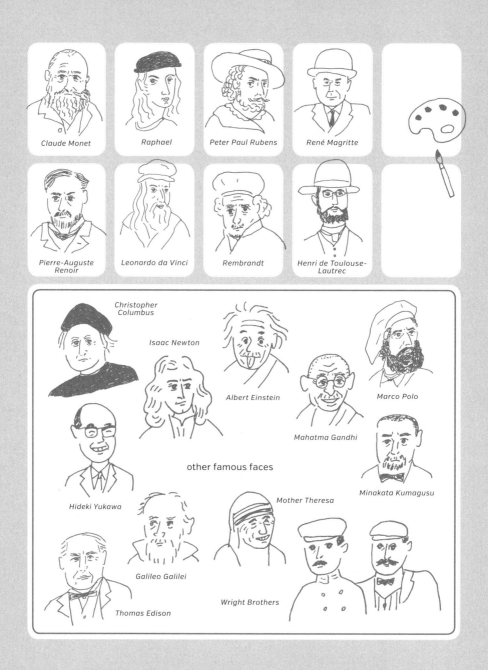

Claude Monet

Raphael

Peter Paul Rubens

René Magritte

Pierre-Auguste Renoir

Leonardo da Vinci

Rembrandt

Henri de Toulouse-Lautrec

Christopher Columbus

Isaac Newton

Albert Einstein

Marco Polo

Mahatma Gandhi

other famous faces

Hideki Yukawa

Minakata Kumagusu

Mother Theresa

Galileo Galilei

Wright Brothers

Thomas Edison

Plants

- Trees
- Shrubs
- Flowers
- Other Unique Plants

Trees

Pay attention to the color and shape of both the leaves and trunk, as these details will make the tree species identifiable.

Broadleaf trees have wide leaves.

tree

You can draw both broadleaf and coniferous trees accurately by including just a few simple details.

broadleaf tree = round

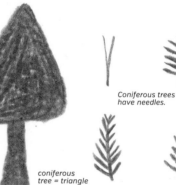

trunk

Coniferous trees have needles.

coniferous tree = triangle

grove

Leave wide spaces between each tree.

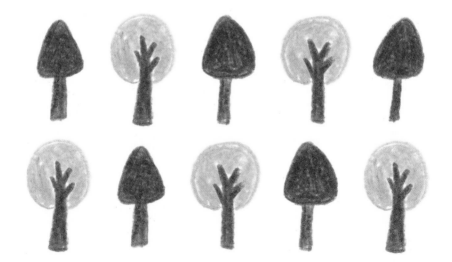

woods

*Draw thick leaves and position
the trees close together.*

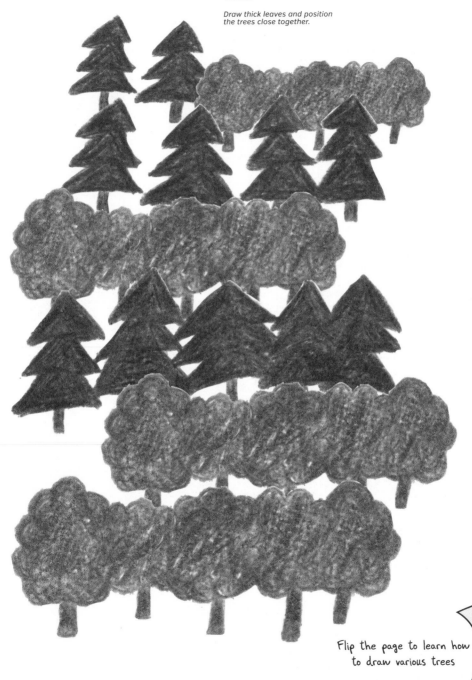

Flip the page to learn how
to draw various trees

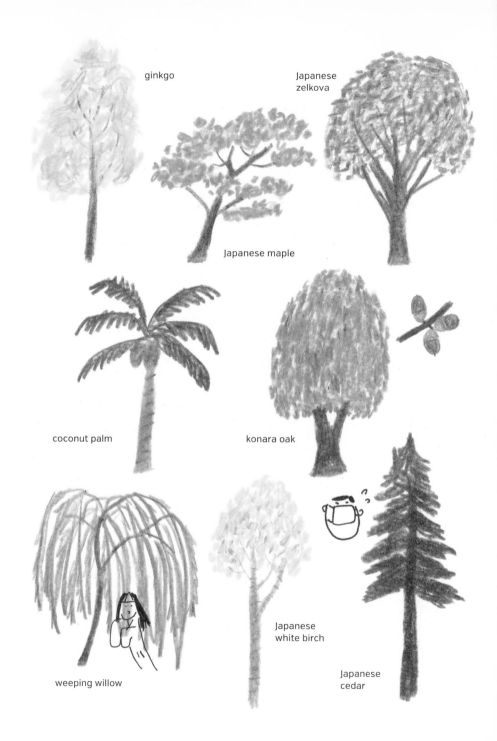

ginkgo

Japanese
zelkova

Japanese maple

coconut palm

konara oak

weeping willow

Japanese
white birch

Japanese
cedar

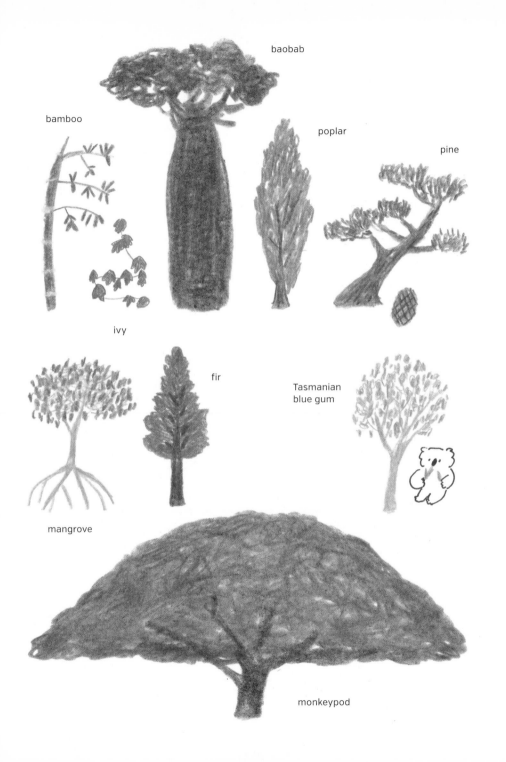

baobab

bamboo

poplar

pine

ivy

fir

Tasmanian
blue gum

mangrove

monkeypod

Shrubs

Draw the petals as accurately as possible since many shrubs have similarly shaped flowers.

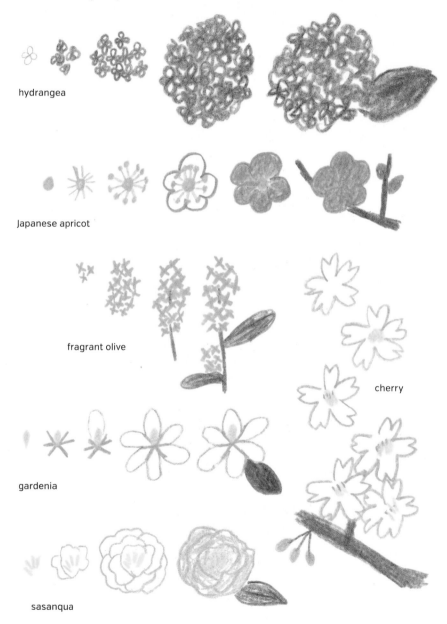

hydrangea

Japanese apricot

fragrant olive

cherry

gardenia

sasanqua

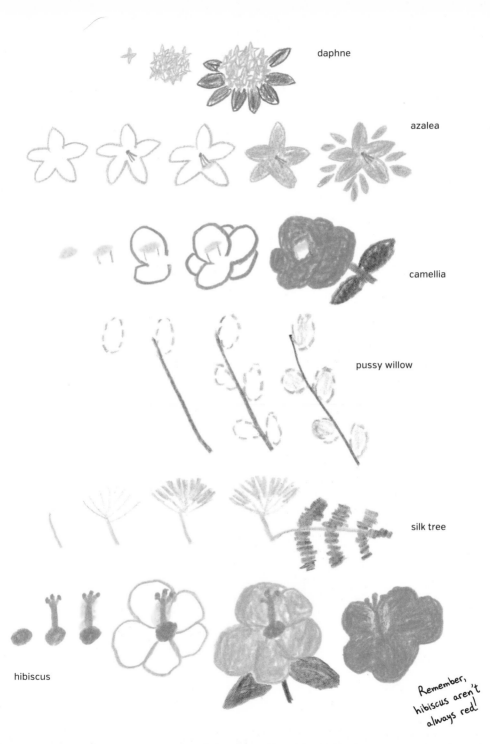

daphne

azalea

camellia

pussy willow

silk tree

hibiscus

Remember, hibiscus aren't always red!

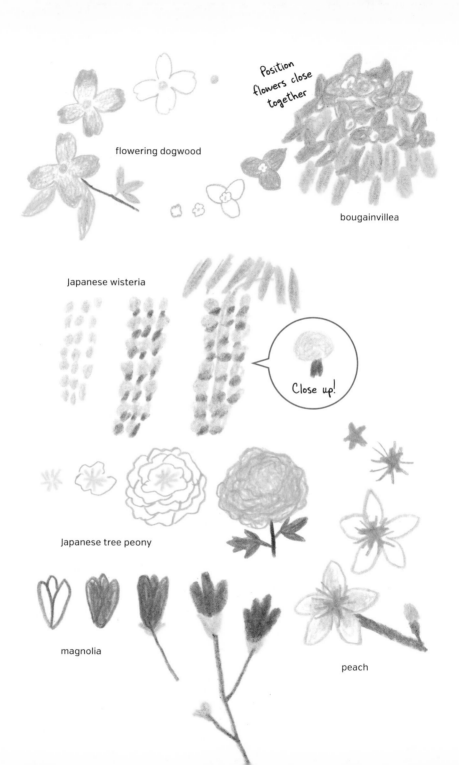

flowering dogwood

Position flowers close together

bougainvillea

Japanese wisteria

Close up!

Japanese tree peony

magnolia

peach

Flowers

Although a flower's colorful petals may catch your eye, don't forget to pay attention to the shape of the leaves— each flower has unique foliage.

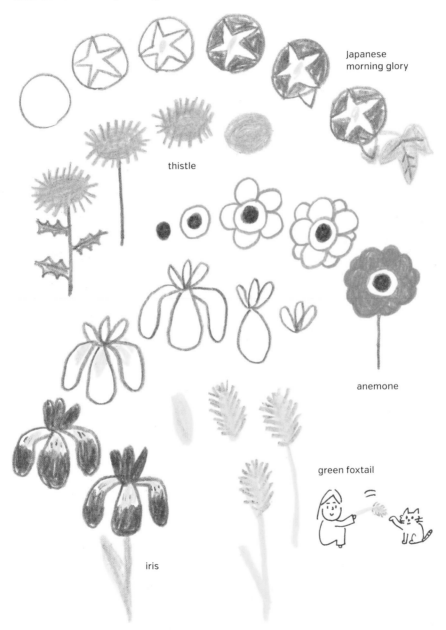

Japanese morning glory

thistle

anemone

green foxtail

iris

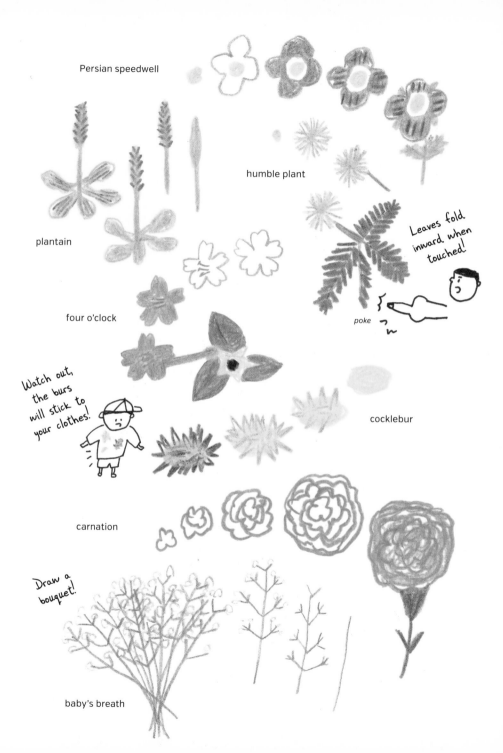

Persian speedwell

plantain

humble plant

Leaves fold inward when touched!

poke

four o'clock

Watch out, the burs will stick to your clothes!

cocklebur

carnation

Draw a bouquet!

baby's breath

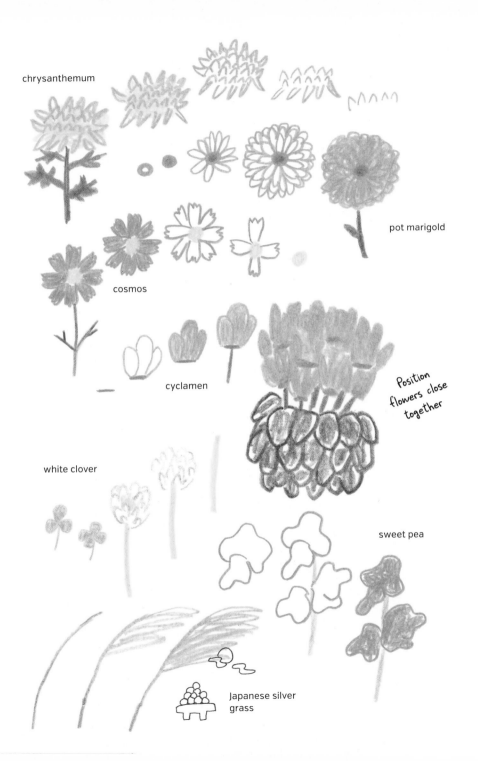

chrysanthemum

pot marigold

cosmos

cyclamen

Position flowers close together

white clover

sweet pea

Japanese silver grass

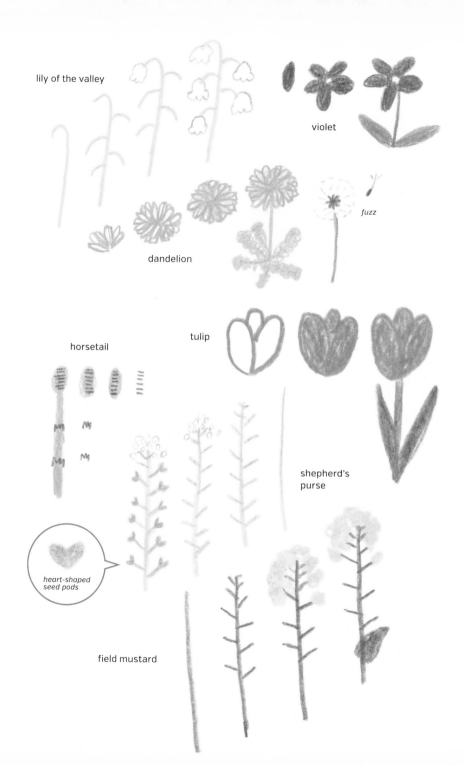

lily of the valley

violet

dandelion

fuzz

horsetail

tulip

shepherd's
purse

heart-shaped
seed pods

field mustard

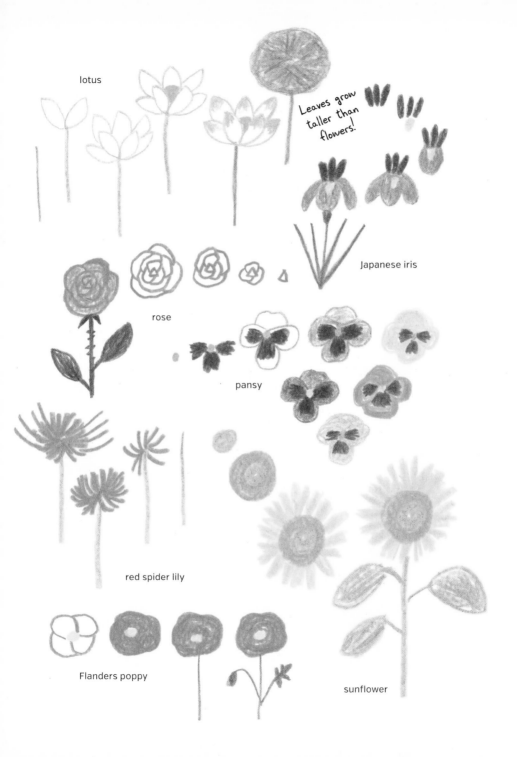

lotus

Leaves grow taller than flowers!

Japanese iris

rose

pansy

red spider lily

Flanders poppy

sunflower

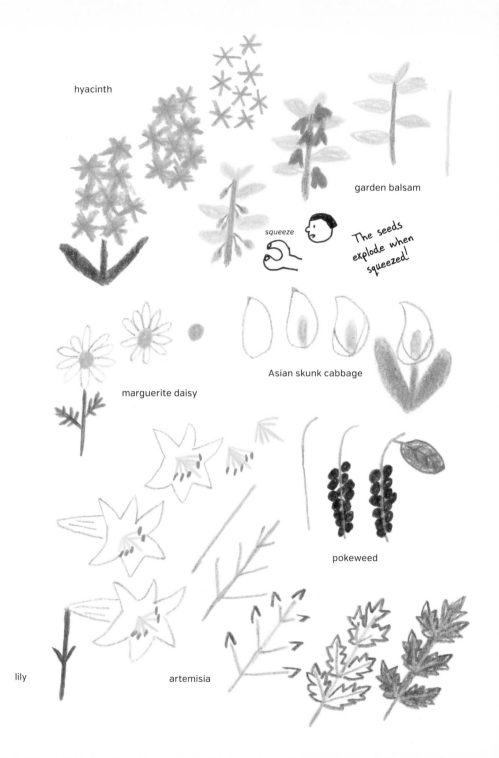

hyacinth

garden balsam

squeeze

The seeds explode when squeezed!

marguerite daisy

Asian skunk cabbage

pokeweed

lily

artemisia

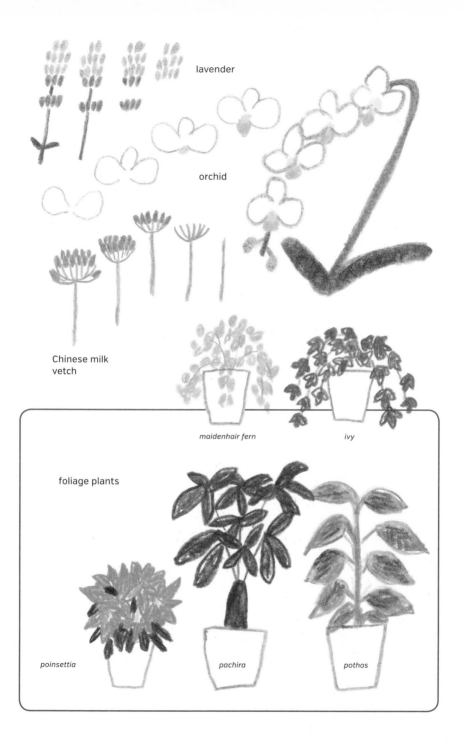

lavender

orchid

Chinese milk vetch

maidenhair fern

ivy

foliage plants

poinsettia

pachira

pothos

Other Unique Plants

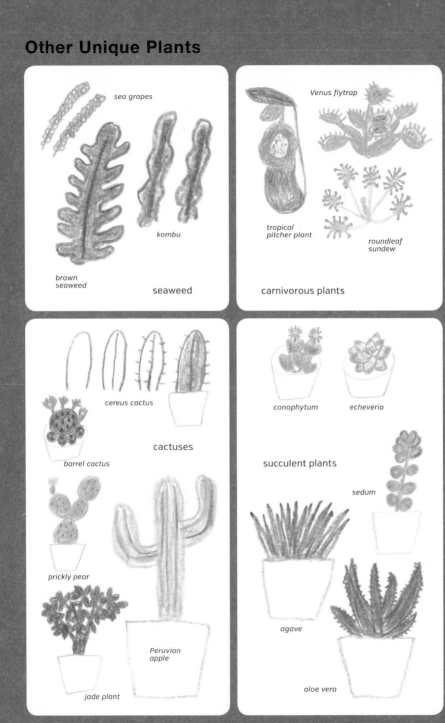

sea grapes

kombu

brown
seaweed

seaweed

Venus flytrap

tropical
pitcher plant

roundleaf
sundew

carnivorous plants

cereus cactus

barrel cactus

cactuses

prickly pear

Peruvian
apple

jade plant

conophytum

echeveria

succulent plants

sedum

agave

aloe vera

Foods

 Fruits

 Vegetables

 Main Dishes

Snacks

Drinks

Packaged Foods

Fruits

Draw clean curves to keep
your fruit looking fresh.

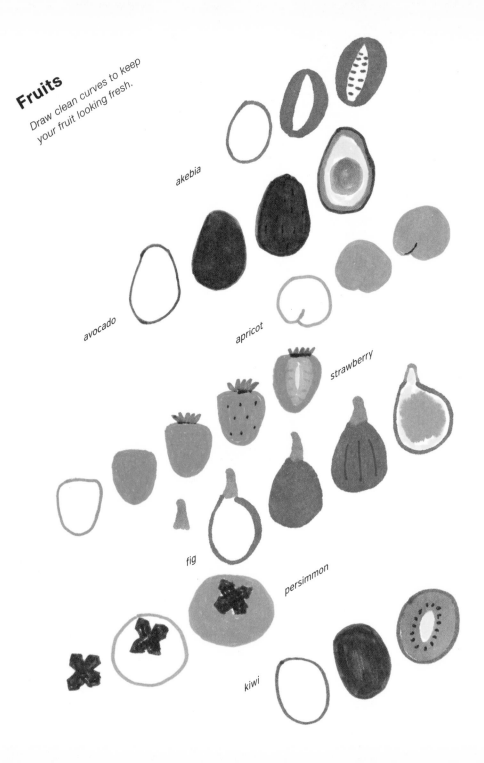

akebia

avocado

apricot

strawberry

fig

persimmon

kiwi

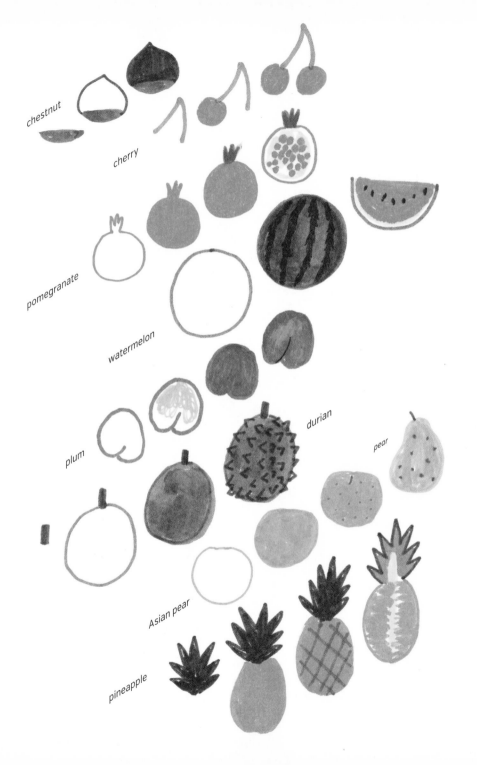

chestnut

cherry

pomegranate

watermelon

plum

durian

pear

Asian pear

pineapple

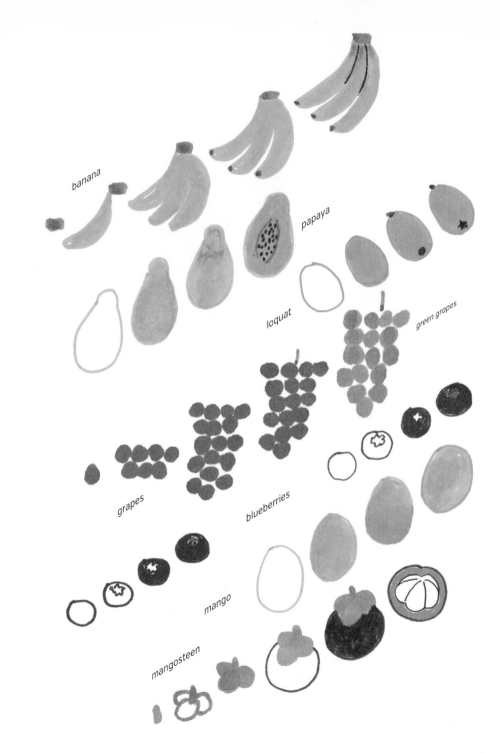

banana

papaya

loquat

green grapes

grapes

blueberries

mango

mangosteen

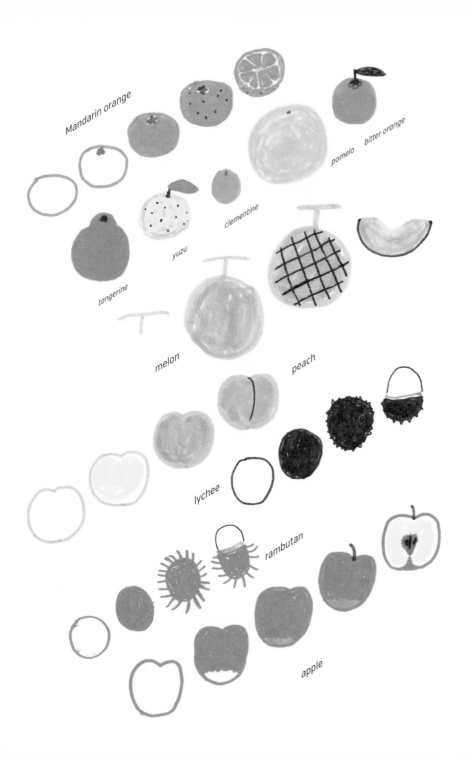

Mandarin orange

pomelo bitter orange

clementine

yuzu

tangerine

melon

peach

lychee

rambutan

apple

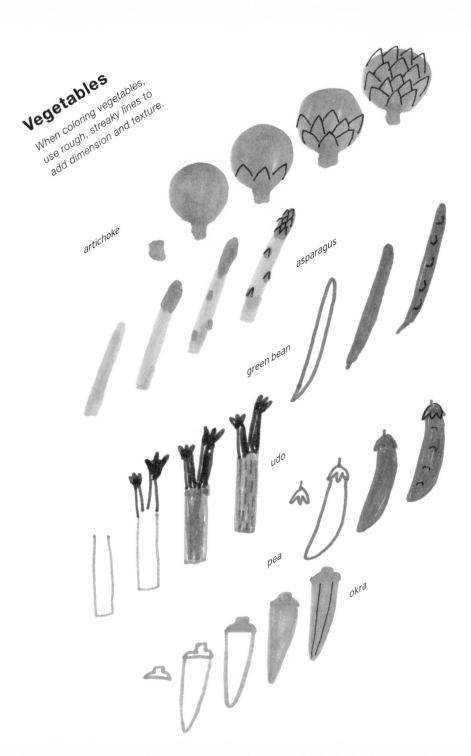

Vegetables

When coloring vegetables, use rough, streaky lines to add dimension and texture.

artichoke

asparagus

green bean

udo

pea

okra

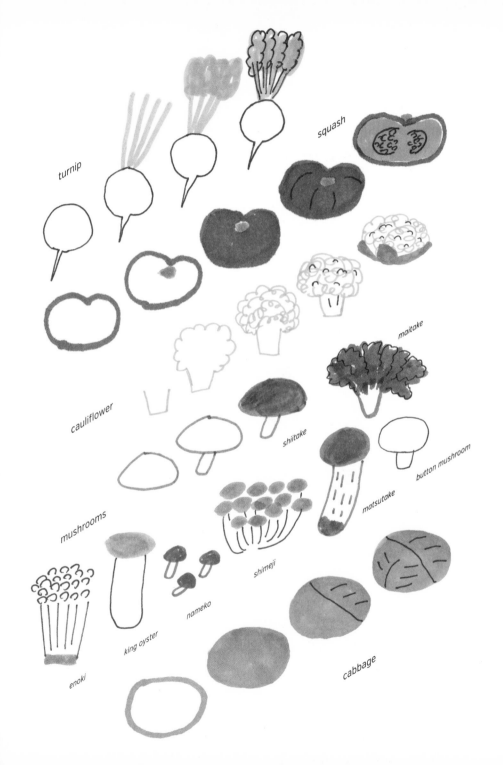

turnip

squash

maitake

cauliflower

shiitake

button mushroom

matsutake

mushrooms

shimeji

enoki

king oyster

nameko

cabbage

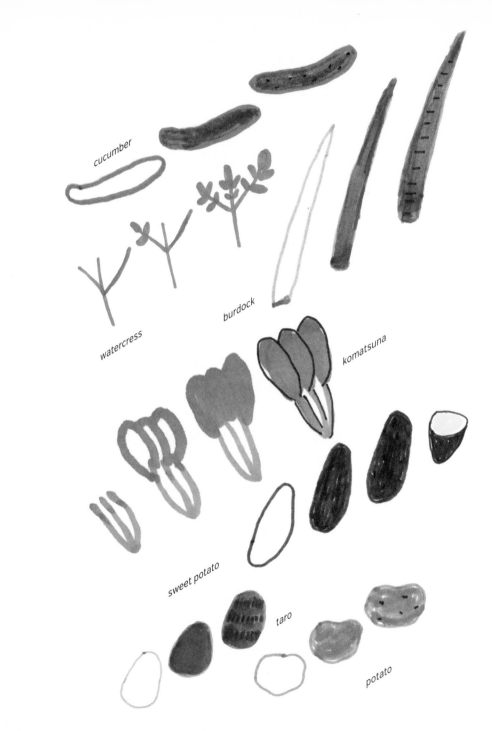

cucumber

watercress

burdock

komatsuna

sweet potato

taro

potato

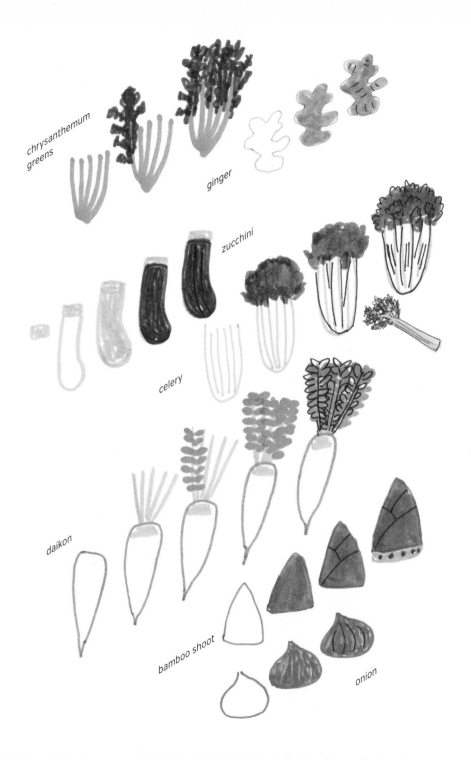

chrysanthemum greens

ginger

zucchini

celery

daikon

bamboo shoot

onion

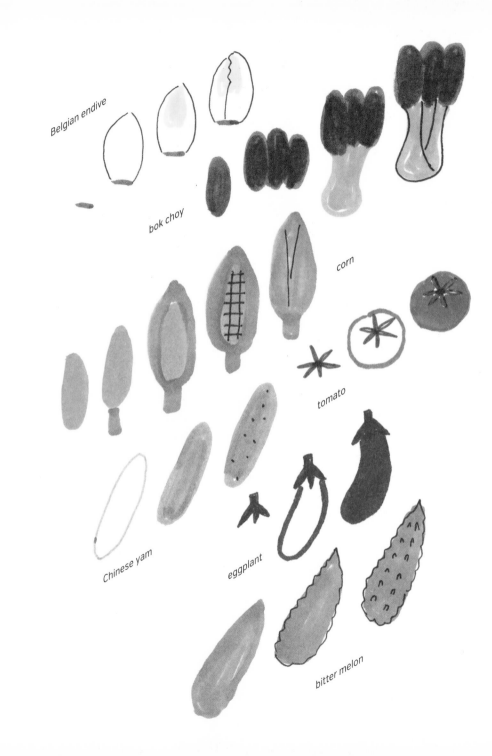

Belgian endive

bok choy

corn

tomato

Chinese yam

eggplant

bitter melon

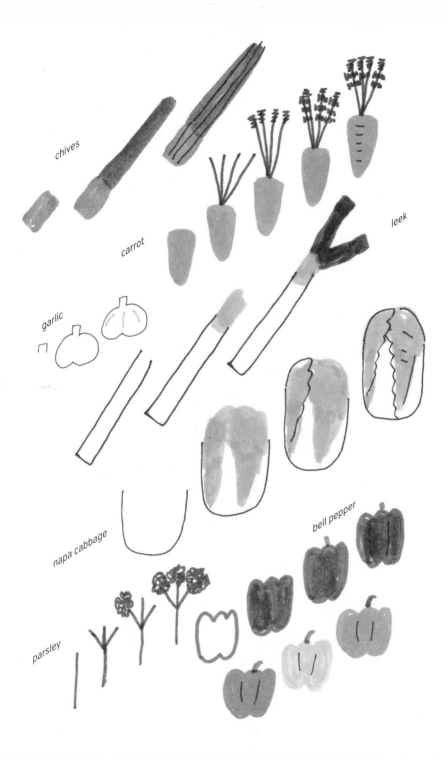

chives

carrot

leek

garlic

napa cabbage

bell pepper

parsley

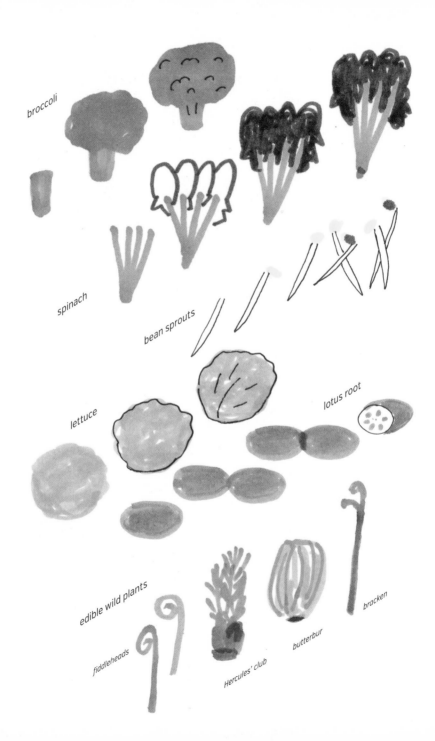

broccoli

spinach

bean sprouts

lettuce

lotus root

edible wild plants

fiddleheads

Hercules' club

butterbur

bracken

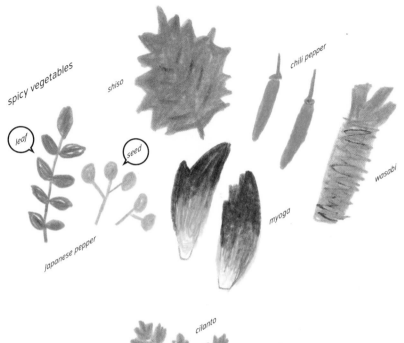

spicy vegetables

shiso

chili pepper

leaf

seed

wasabi

myoga

Japanese pepper

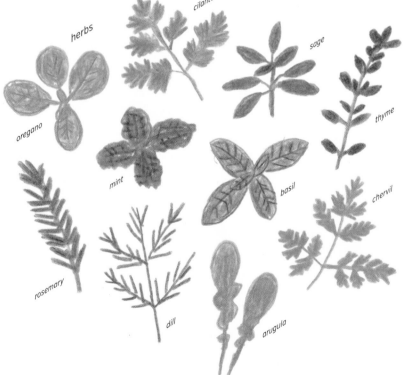

herbs

cilanto

sage

thyme

oregano

mint

basil

chervil

rosemary

dill

arugula

Main Dishes

When drawing main dishes, it helps to think about the way you serve each meal. Which ingredients are visible when the dish is plated? Is the dish traditionally served with certain garnishes or condiments? These details help make an illustration more accurate.

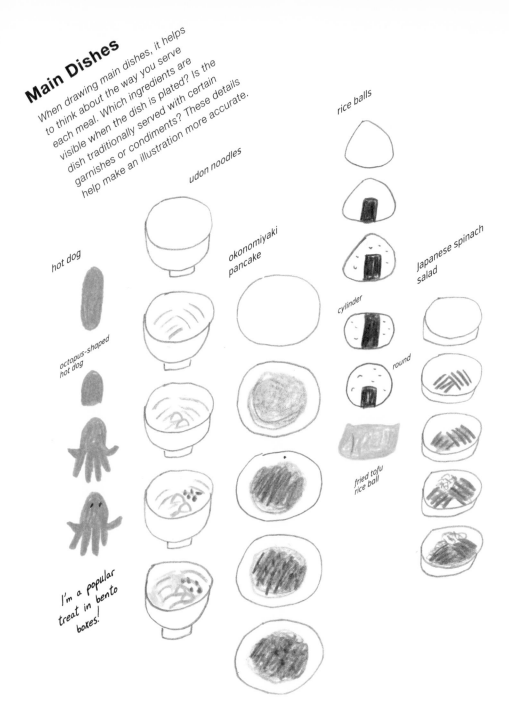

rice balls

udon noodles

okonomiyaki pancake

hot dog

cylinder

Japanese spinach salad

octopus-shaped hot dog

round

fried tofu rice ball

I'm a popular treat in bento boxes!

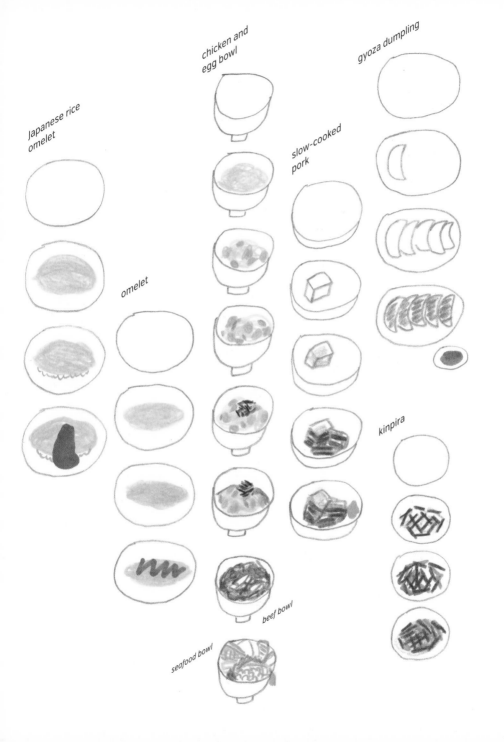

Japanese rice omelet

omelet

chicken and egg bowl

slow-cooked pork

gyoza dumpling

kinpira

beef bowl

seafood bowl

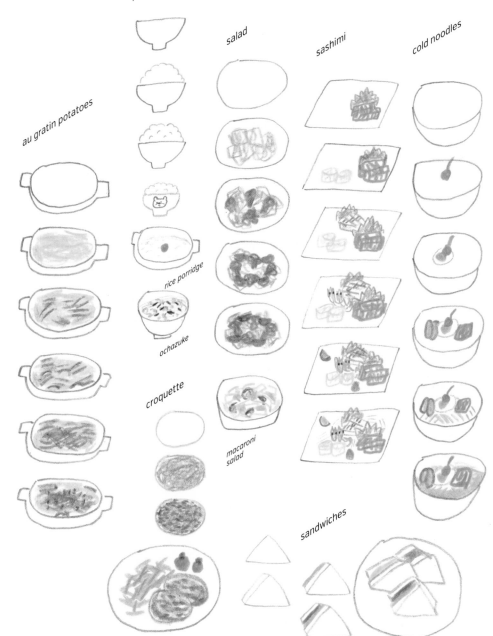

rice

salad

sashimi

cold noodles

au gratin potatoes

rice porridge

ochazuke

croquette

macaroni salad

sandwiches

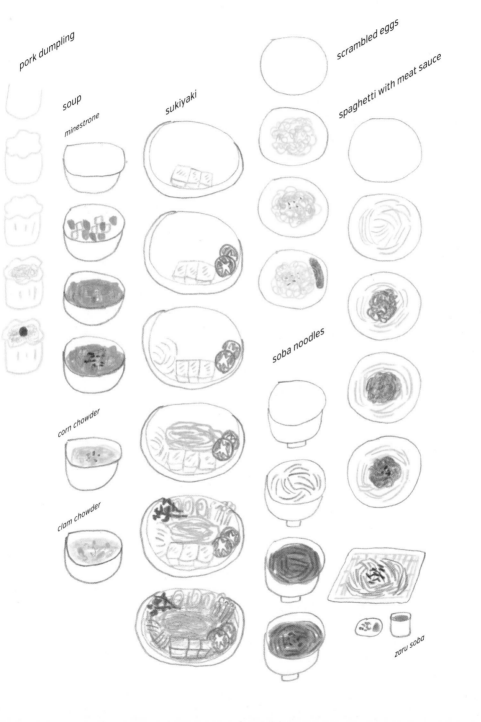

pork dumpling

soup

minestrone

corn chowder

clam chowder

sukiyaki

soba noodles

scrambled eggs

spaghetti with meat sauce

zaru soba

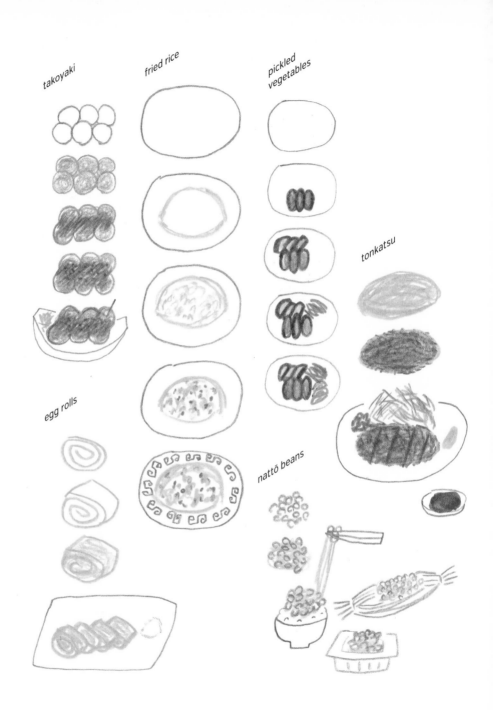

takoyaki

fried rice

pickled vegetables

tonkatsu

egg rolls

nattō beans

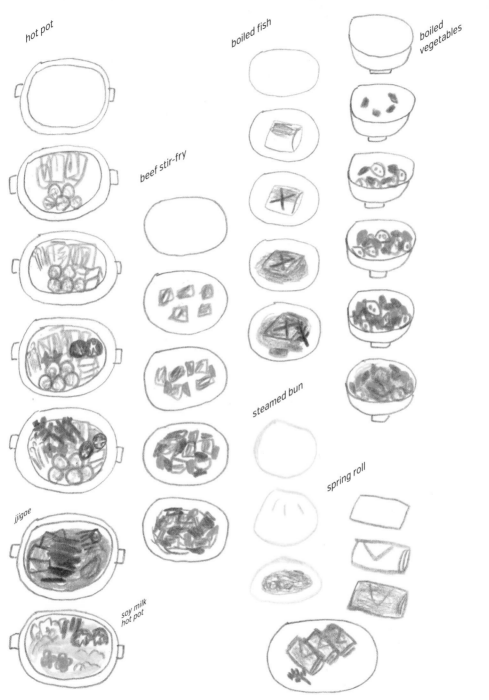

hot pot

boiled fish

boiled vegetables

beef stir-fry

steamed bun

spring roll

jjigae

soy milk hot pot

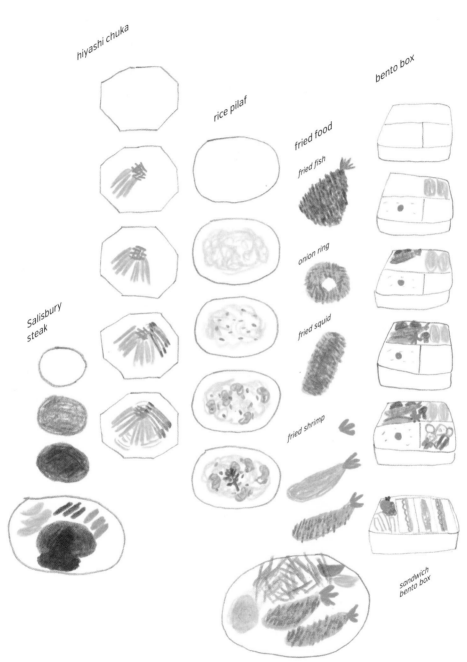

hiyashi chuka

rice pilaf

bento box

fried food

fried fish

onion ring

fried squid

fried shrimp

Salisbury
steak

sandwich
bento box

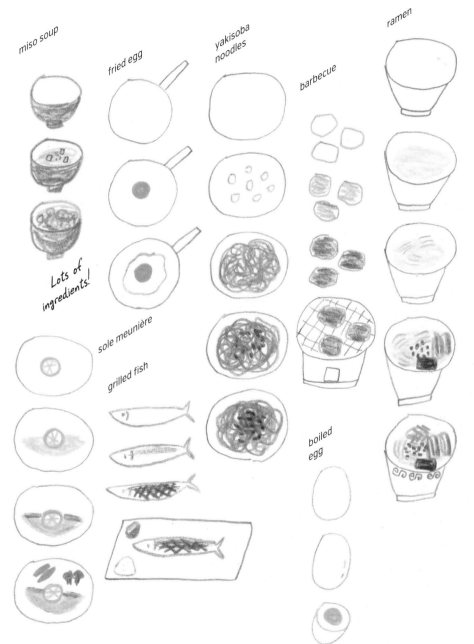

miso soup

fried egg

yakisoba noodles

ramen

barbecue

Lots of ingredients!

sole meunière

grilled fish

boiled egg

Dishes of the World

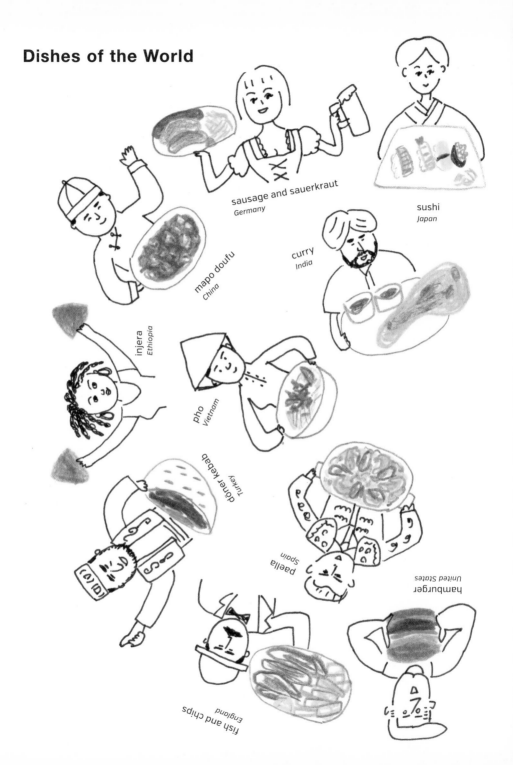

sausage and sauerkraut
Germany

sushi
Japan

mapo doufu
China

curry
India

injera
Ethiopia

pho
Vietnam

döner kebab
Turkey

paella
Spain

hamburger
United States

fish and chips
England

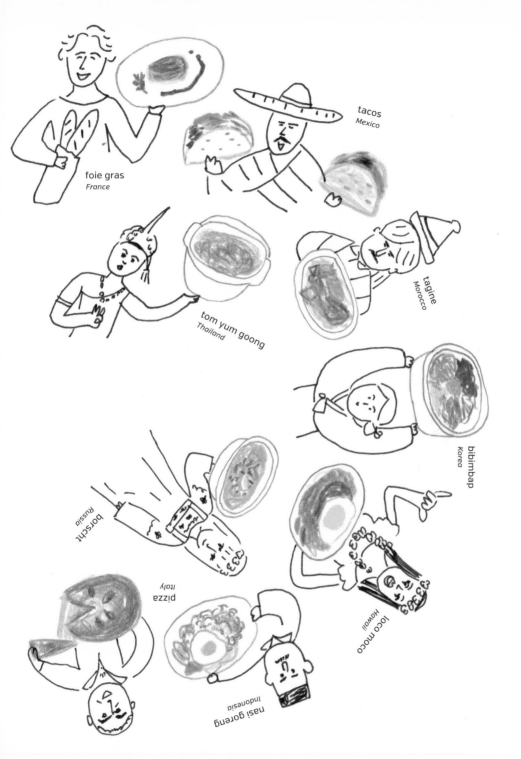

foie gras
France

tacos
Mexico

tom yum goong
Thailand

tagine
Morocco

bibimbap
Korea

borscht
Russia

loco moco
Hawaii

pizza
Italy

nasi goreng
Indonesia

Snacks

Use a marker to replicate the smooth, shiny texture of frosting, ice cream, and other sweets.

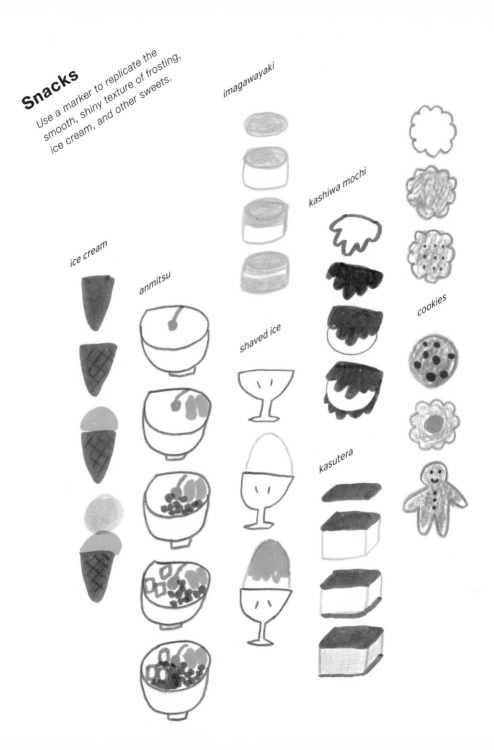

imagawayaki

kashiwa mochi

ice cream

anmitsu

shaved ice

cookies

kasutera

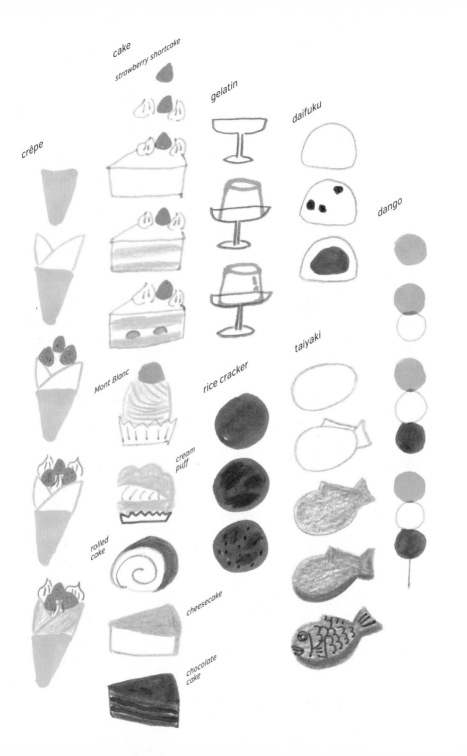

crêpe

cake

strawberry shortcake

gelatin

daifuku

dango

Mont Blanc

rice cracker

taiyaki

cream puff

rolled cake

cheesecake

chocolate cake

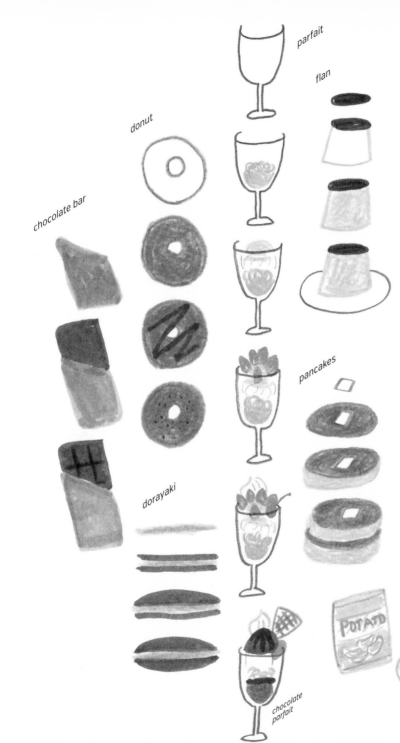

parfait

flan

donut

chocolate bar

pancakes

chips

dorayaki

chocolate parfait

POTATO

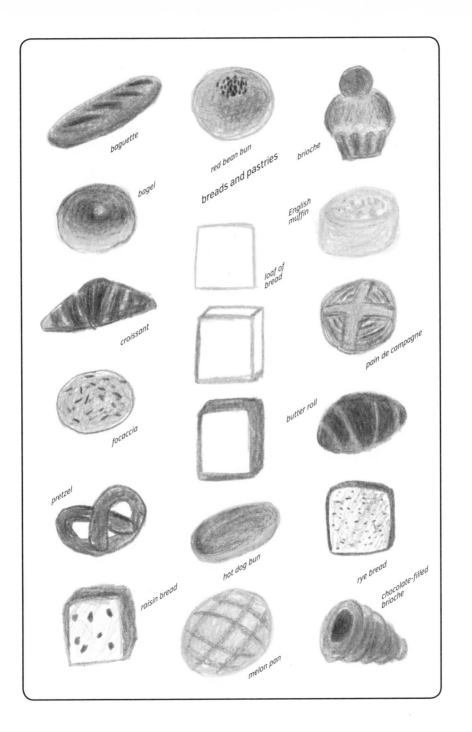

baguette

red bean bun

breads and pastries

brioche

bagel

English muffin

loaf of bread

croissant

pain de campagne

focaccia

butter roll

pretzel

rye bread

raisin bread

hot dog bun

chocolate-filled brioche

melon pan

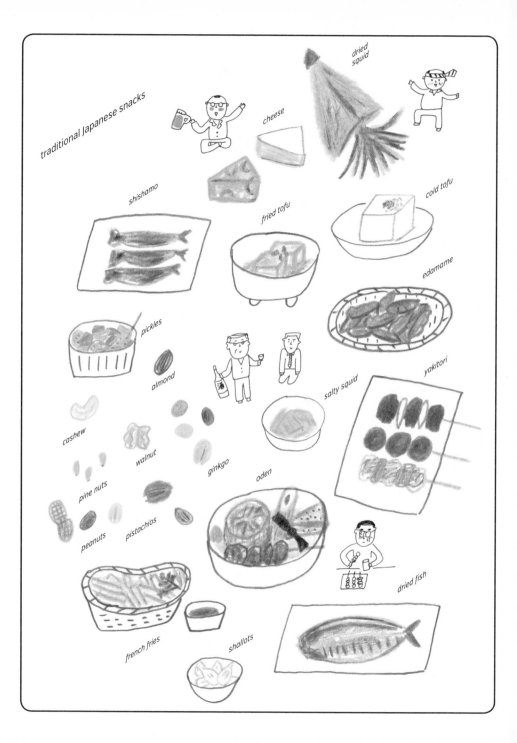

traditional Japanese snacks

dried squid

cheese

shishamo

fried tofu

cold tofu

edamame

pickles

almond

cashew

walnut

ginkgo

salty squid

yakitori

pine nuts

peanuts

pistachios

oden

dried fish

french fries

shallots

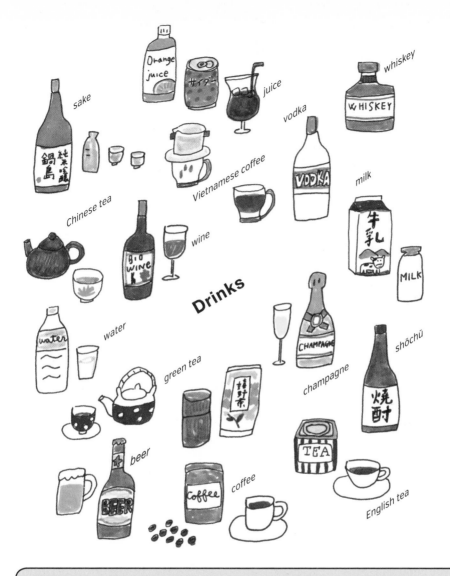

Drinks

sake

Orange juice

juice

whiskey

vodka

Vietnamese coffee

Chinese tea

wine

milk

water

green tea

shōchū

champagne

beer

coffee

English tea

CHALLENGE #2:
Draw Bottles

I like to find bottles with unique shapes and interesting labels to use for drawing practice. These drawings often look best when done in black pen.

Packaged Foods

When drawing packaged foods, think about the shapes of the bottles and jars, the colors of the logos, and the imagery used on the labels.

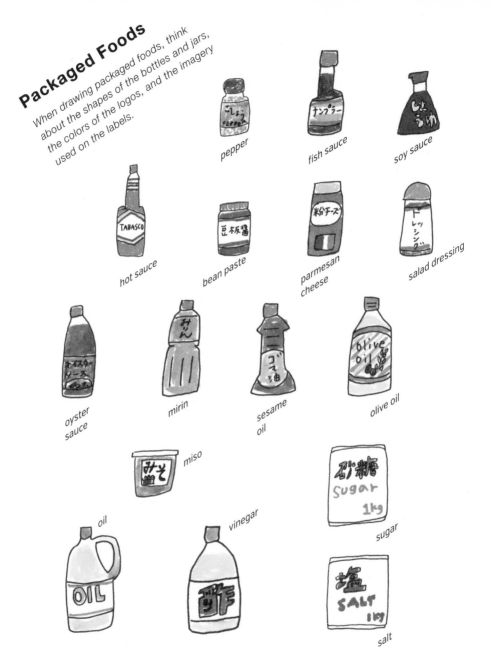

pepper

fish sauce

soy sauce

hot sauce

bean paste

parmesan cheese

salad dressing

oyster sauce

mirin

sesame oil

olive oil

miso

oil

vinegar

sugar

salt

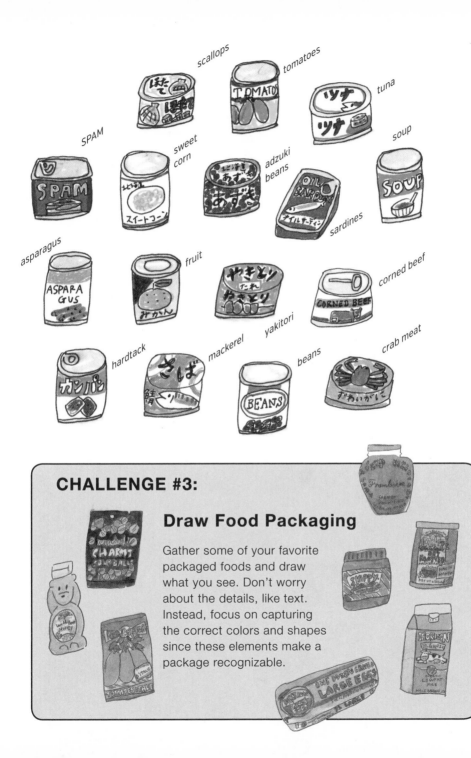

scallops

tomatoes

tuna

SPAM

sweet corn

adzuki beans

soup

sardines

asparagus

fruit

corned beef

hardtack

mackerel

yakitori

beans

crab meat

CHALLENGE #3:

Draw Food Packaging

Gather some of your favorite packaged foods and draw what you see. Don't worry about the details, like text. Instead, focus on capturing the correct colors and shapes since these elements make a package recognizable.

CHALLENGE #4:
Make a Food Journal

I love to create a visual food journal when I travel or visit restaurants. Just like a written diary, a visual diary will help you remember memorable trips and events. In addition to drawing what you ate, add details about the restaurant's atmosphere, service, and best dishes. Here's a tip: Draw first, then add text once the sketch is complete.

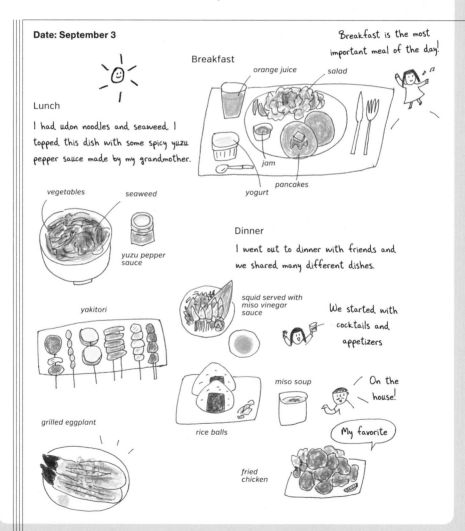

Date: September 3

Breakfast is the most important meal of the day!

Breakfast

orange juice

salad

jam

pancakes

yogurt

Lunch

I had udon noodles and seaweed I topped this dish with some spicy yuzu pepper sauce made by my grandmother.

vegetables

seaweed

yuzu pepper sauce

Dinner

I went out to dinner with friends and we shared many different dishes.

yakitori

squid served with miso vinegar sauce

We started with cocktails and appetizers

miso soup

On the house!

My favorite

grilled eggplant

rice balls

fried chicken

Around the House

Entryway

Kitchen

Living Room

Bedroom

Study

Bathroom

Patio

Home Maintenance

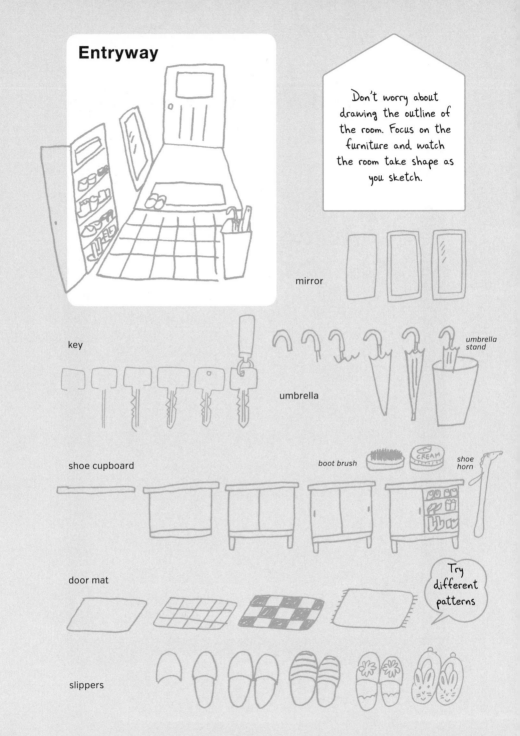

Entryway

Don't worry about drawing the outline of the room. Focus on the furniture and watch the room take shape as you sketch.

mirror

key

umbrella

umbrella stand

shoe cupboard

boot brush

CREAM

shoe horn

door mat

Try different patterns

slippers

Kitchen

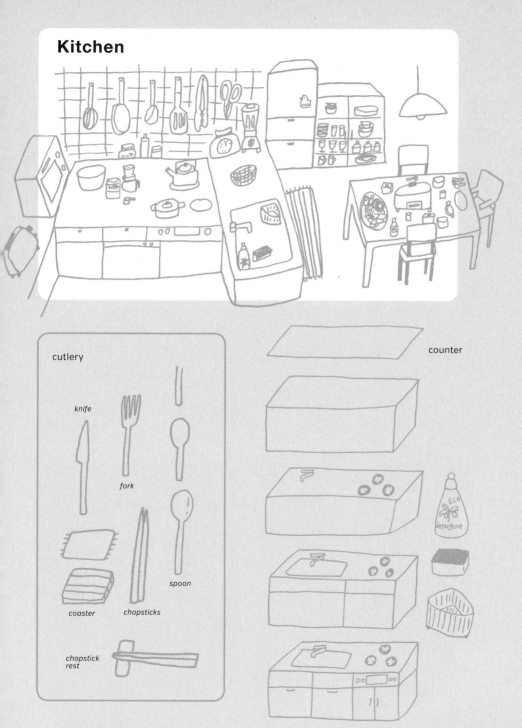

cutlery

knife

fork

spoon

coaster

chopsticks

chopstick
rest

counter

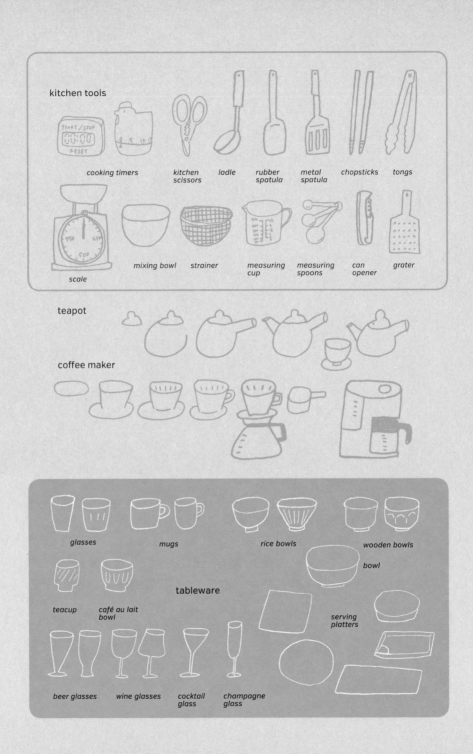

kitchen tools

cooking timers

kitchen scissors

ladle

rubber spatula

metal spatula

chopsticks

tongs

scale

mixing bowl

strainer

measuring cup

measuring spoons

can opener

grater

teapot

coffee maker

glasses

mugs

rice bowls

wooden bowls

bowl

teacup

café au lait bowl

tableware

serving platters

beer glasses

wine glasses

cocktail glass

champagne glass

cupboard

rice cooker

dining table

chair

highchair

storage containers

spice bottles

microwave

toaster

pots and pans

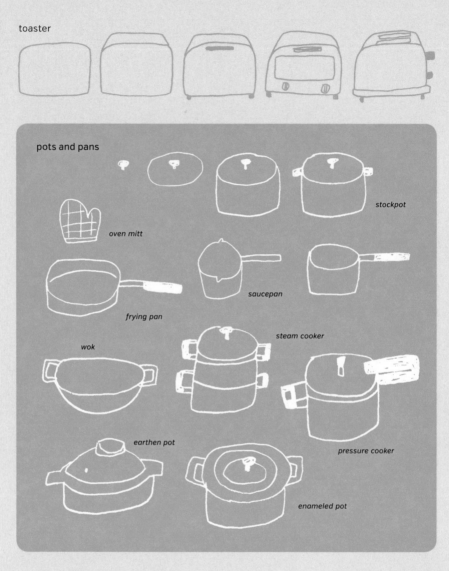

stockpot

oven mitt

frying pan

saucepan

wok

steam cooker

earthen pot

pressure cooker

enameled pot

bread machine

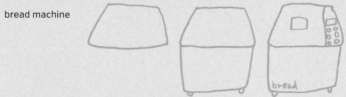

bread

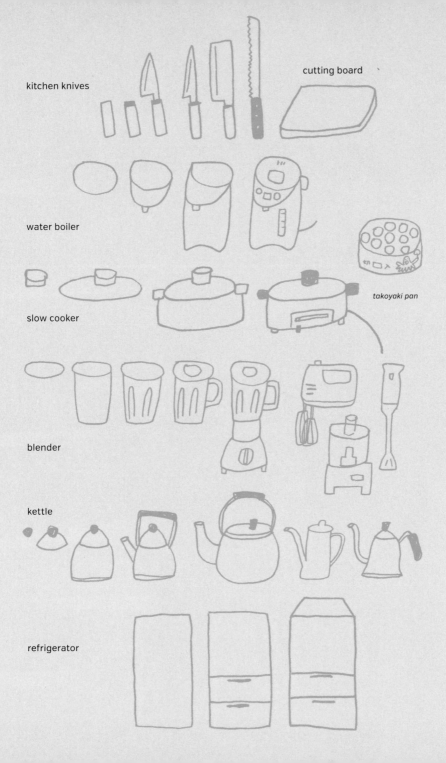

kitchen knives

cutting board

water boiler

takoyaki pan

slow cooker

blender

kettle

refrigerator

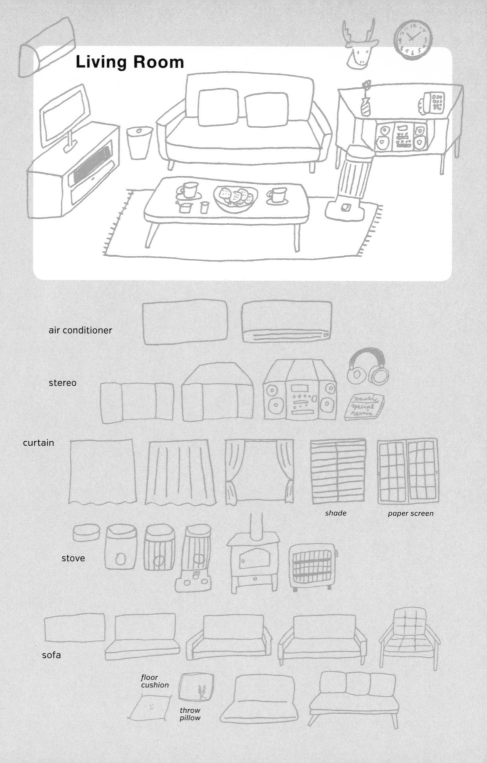

Living Room

air conditioner

stereo

curtain

shade paper screen

stove

sofa

floor
cushion

throw
pillow

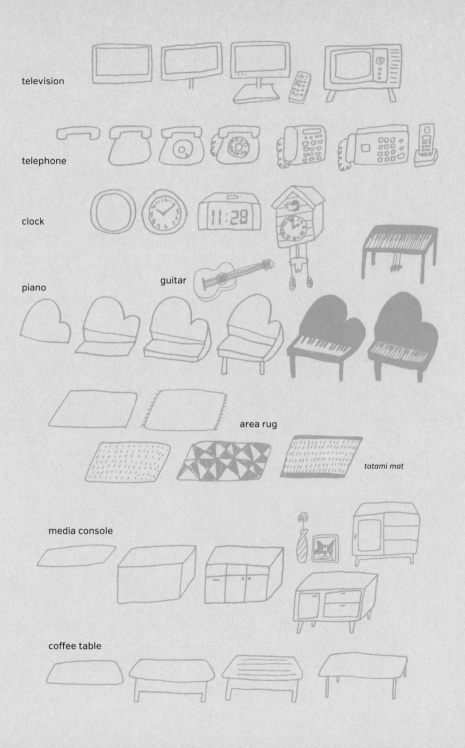

television

telephone

clock

piano

guitar

area rug

tatami mat

media console

coffee table

Bedroom

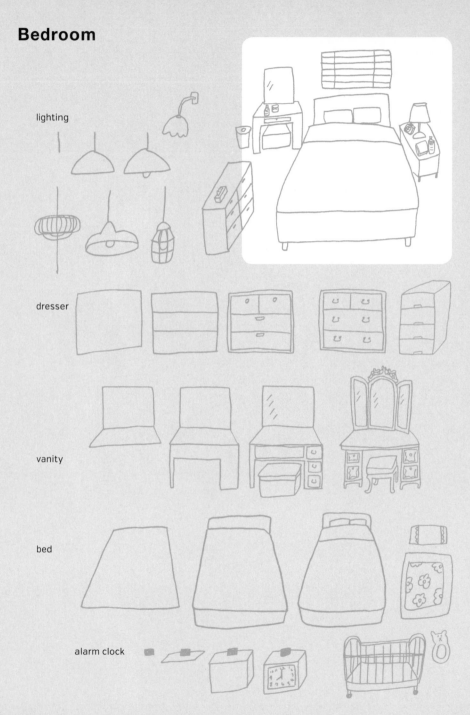

lighting

dresser

vanity

bed

alarm clock

Study

waste basket

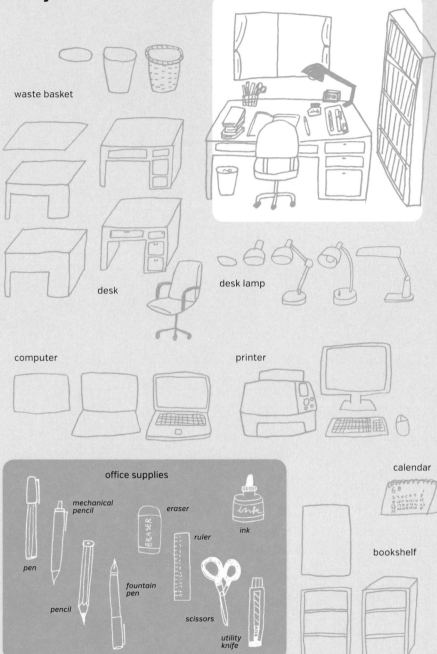

desk

desk lamp

computer

printer

office supplies

pen

mechanical pencil

eraser

ink

ruler

pencil

fountain pen

scissors

utility knife

calendar

bookshelf

Bathroom

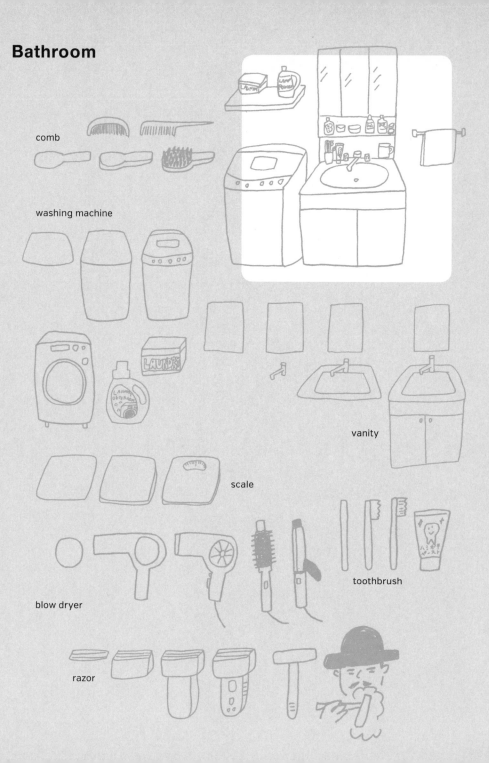

comb

washing machine

vanity

scale

blow dryer

toothbrush

razor

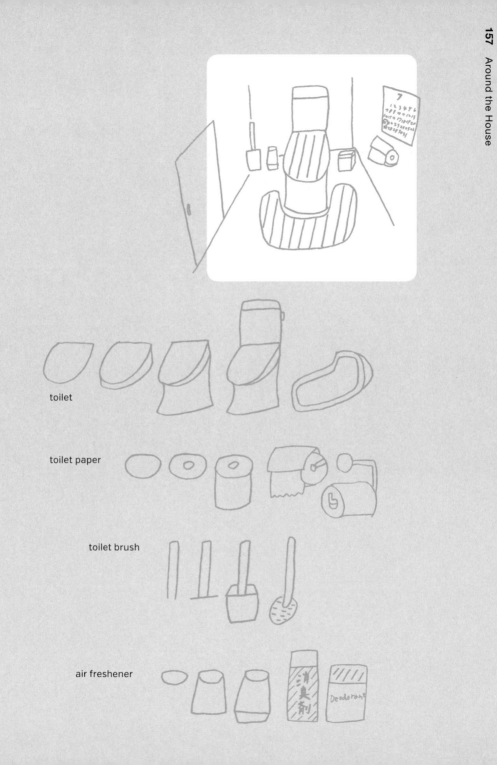

toilet

toilet paper

toilet brush

air freshener

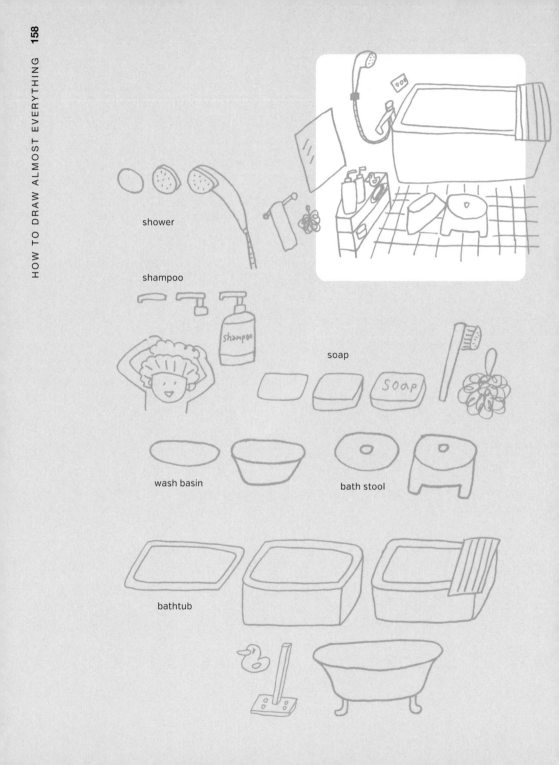

shower

shampoo

soap

wash basin

bath stool

bathtub

Patio

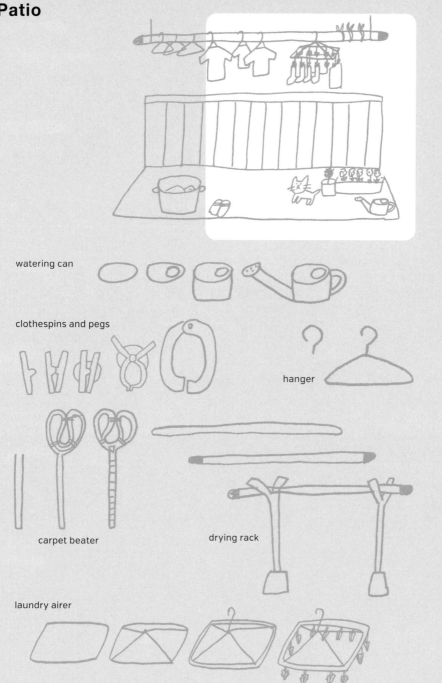

watering can

clothespins and pegs

hanger

carpet beater

drying rack

laundry airer

Home Maintenance

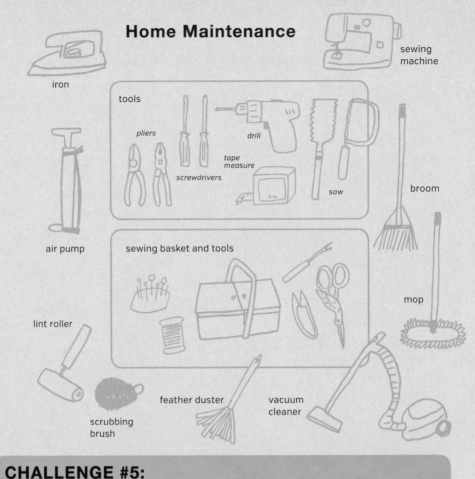

iron

sewing machine

tools

pliers

drill

screwdrivers

tape measure

saw

broom

air pump

sewing basket and tools

mop

lint roller

scrubbing brush

feather duster

vacuum cleaner

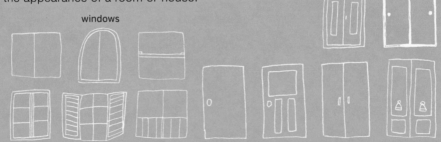

CHALLENGE #5:

Draw Windows and Doors

Practice drawing different styles of windows and doors, as these architectural elements can completely change the appearance of a room or house.

doors

windows

Architectures
and Sites

Around the Neighborhood

Famous Sites in Japan

Famous Sites Around the World

Around the Neighborhood

When drawing a building, start with a rough outline, then add
features like windows, doors, and signs.

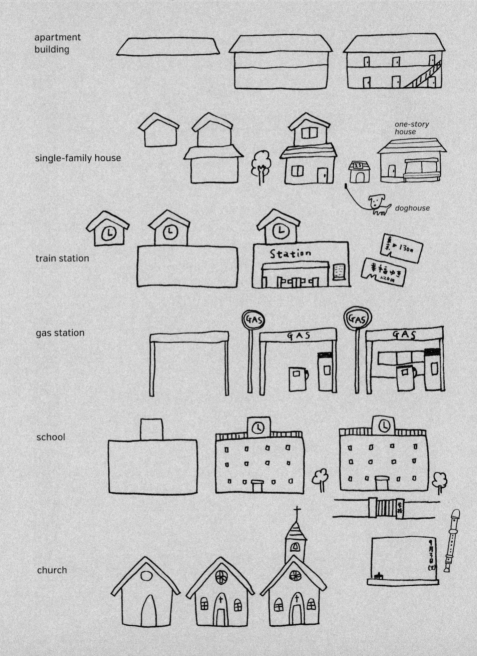

apartment
building

single-family house

one-story
house

doghouse

train station

gas station

school

church

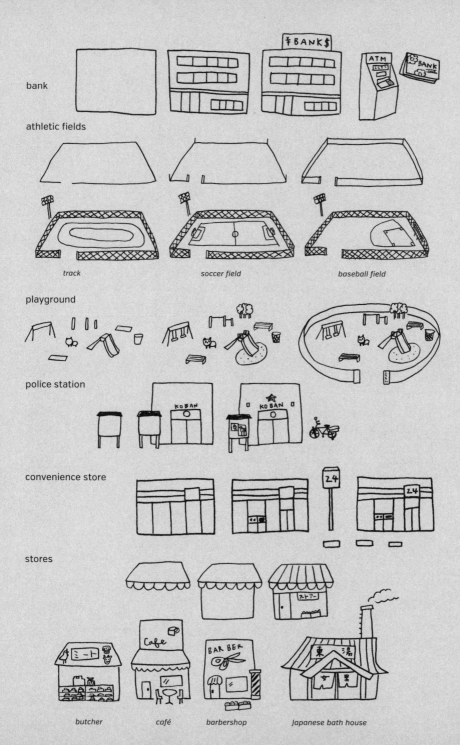

bank

athletic fields

track *soccer field* *baseball field*

playground

police station

convenience store

stores

butcher *café* *barbershop* *Japanese bath house*

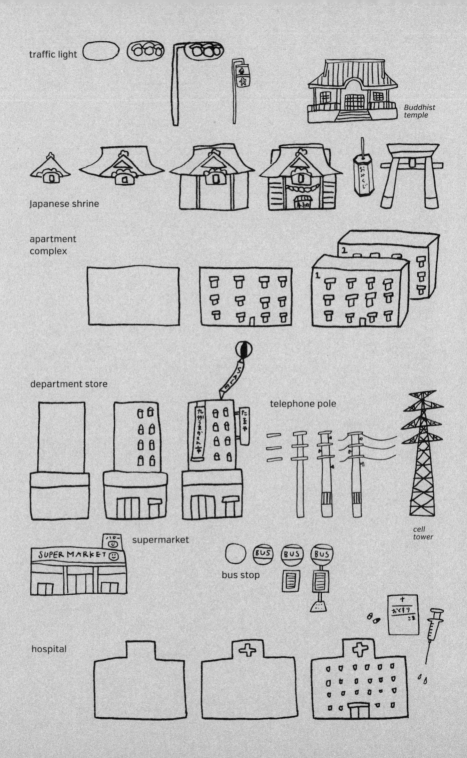

traffic light

Buddhist temple

Japanese shrine

apartment complex

department store

telephone pole

cell tower

supermarket

bus stop

hospital

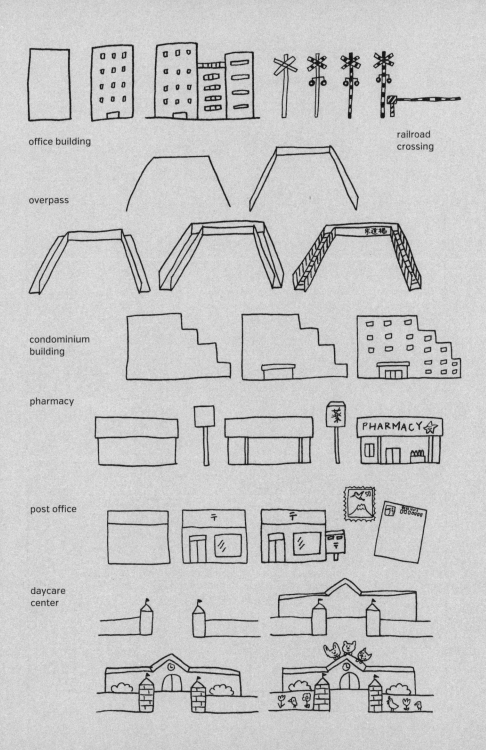

office building

railroad crossing

overpass

condominium building

pharmacy

post office

daycare center

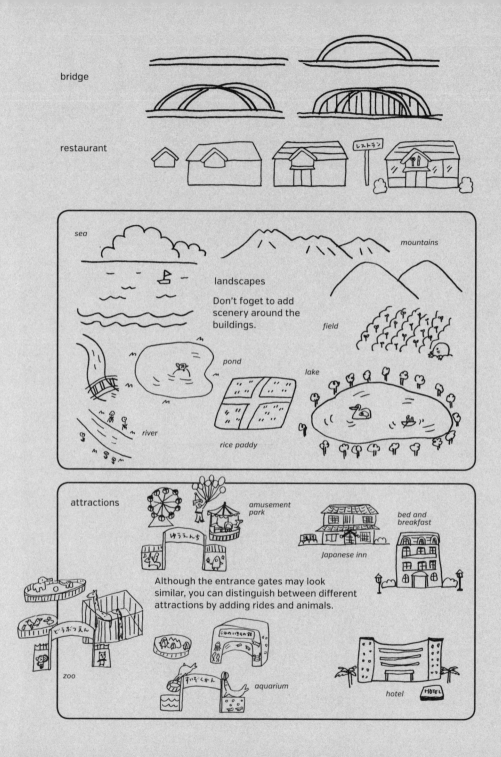

bridge

restaurant

sea

mountains

landscapes

Don't foget to add scenery around the buildings.

field

pond

lake

river

rice paddy

attractions

amusement park

bed and breakfast

Japanese inn

Although the entrance gates may look similar, you can distinguish between different attractions by adding rides and animals.

zoo

aquarium

hotel

CHALLENGE #6:

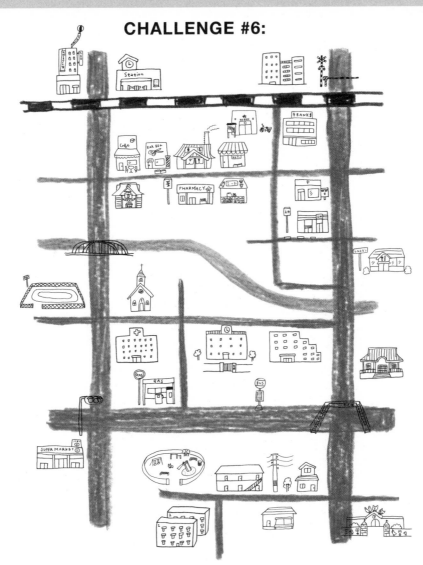

Draw a Street Map

Creating a map is a perfect way to practice drawing buildings and other neighborhood sites. Start out by drawing major roads, side streets, railroad tracks, and rivers. Then add buildings and other important landmarks. Being able to incorporate illustrations into your maps is a great skill to possess—it will make your directions much easier to follow.

Famous Sites in Japan

When drawing a building or landmark, start with the largest components of the structure, such as the roof, columns, or beams.

Izumo Taisha Shrine

Itsukushima Jinja Shrine

Thunder Gate

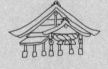

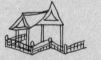

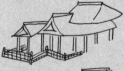

Gassho-zukuri

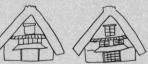

Kiyomizudera Temple

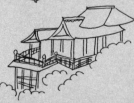

Golden Pavilion

National Diet Building

Shuri Castle

Tokyo Skytree

Tokyo Tower

Silver Pavilion

Five-Story Pagoda of To-ji Temple

Yakushi-ji Temple

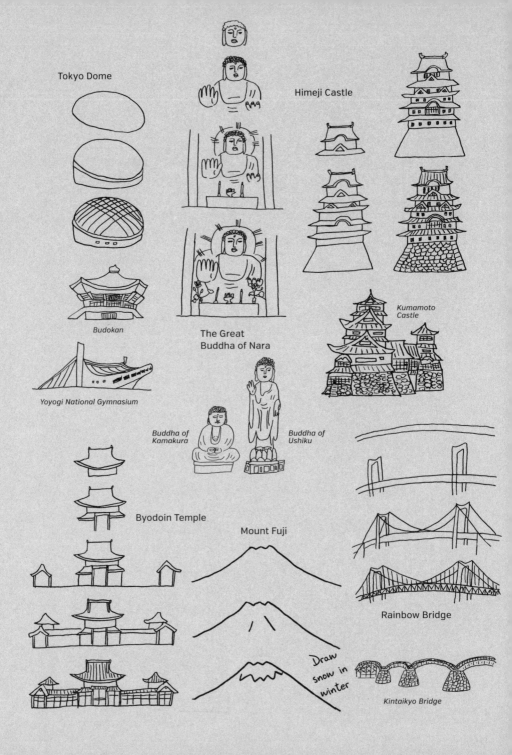

Tokyo Dome

Himeji Castle

Budokan

The Great Buddha of Nara

Yoyogi National Gymnasium

Kumamoto Castle

Buddha of Kamakura

Buddha of Ushiku

Byodoin Temple

Mount Fuji

Rainbow Bridge

Draw snow in winter

Kintaikyo Bridge

Famous Sites Around the World

Don't forget to add detail! Many of these famous landmarks are known for their elegant and elaborate decorations.

Arc de Triomphe

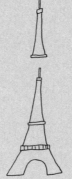

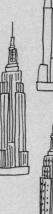

Angkor Wat

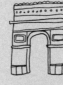

Eiffel Tower

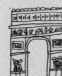

Empire State Building

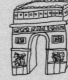

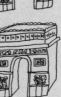

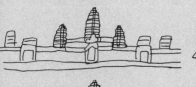

Chrysler Building

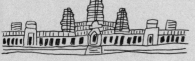

Palais Garnier

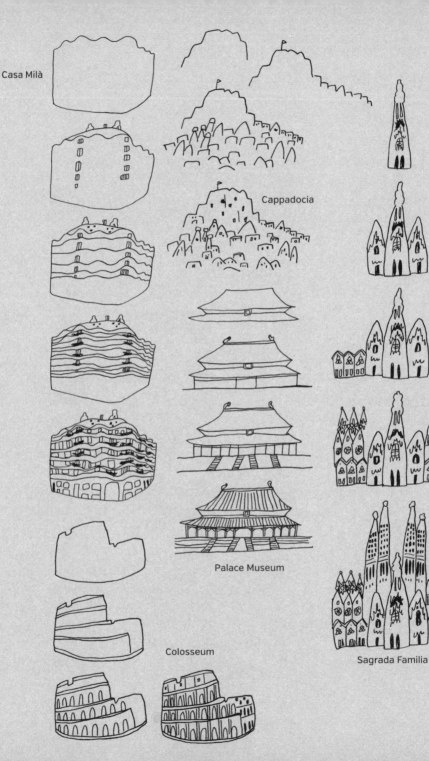

Casa Milà

Cappadocia

Palace Museum

Colosseum

Sagrada Familia

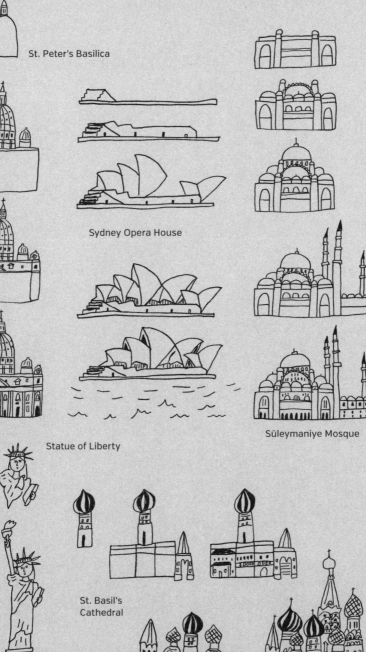

St. Peter's Basilica

Sydney Opera House

Süleymaniye Mosque

Statue of Liberty

St. Basil's Cathedral

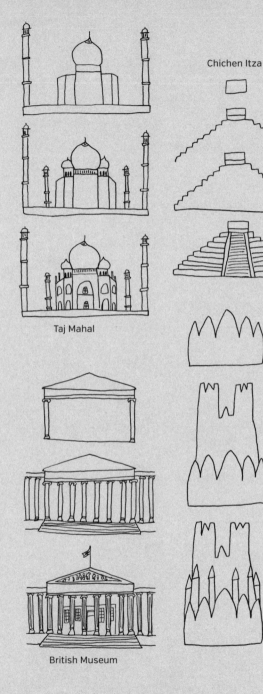

Taj Mahal

Chichen Itza

British Museum

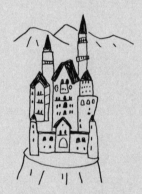

Neuschwanstein Castle

Notre-Dame Cathedral

Parthenon

Great Wall of China

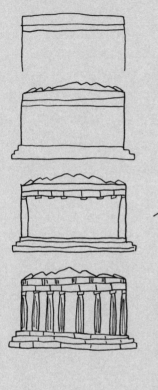

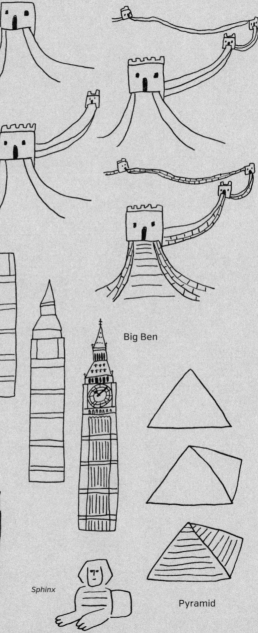

Leaning Tower of Pisa

Big Ben

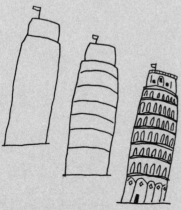

Sphinx

Pyramid

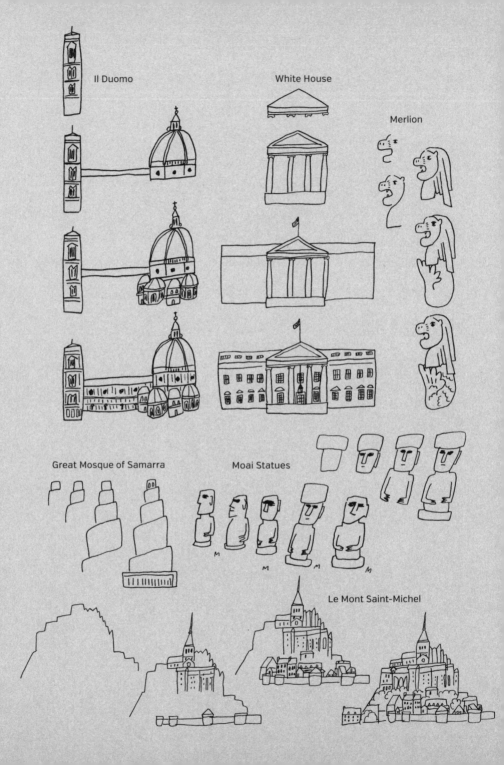

Il Duomo

White House

Merlion

Great Mosque of Samarra

Moai Statues

Le Mont Saint-Michel

Vehicles

On the Road

On the Tracks

In the Air

On the Water

Other Vehicles

On the Road

Pay special attention to the wheels when drawing road vehicles. Notice how the position and size of the wheels changes for each vehicle.

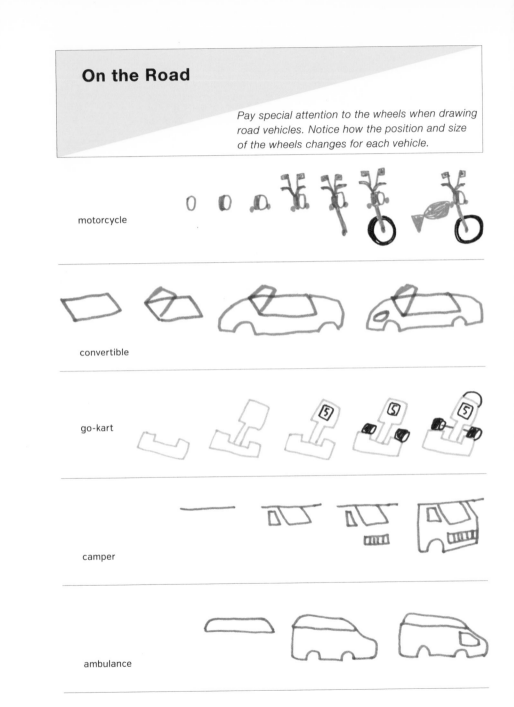

motorcycle

convertible

go-kart

camper

ambulance

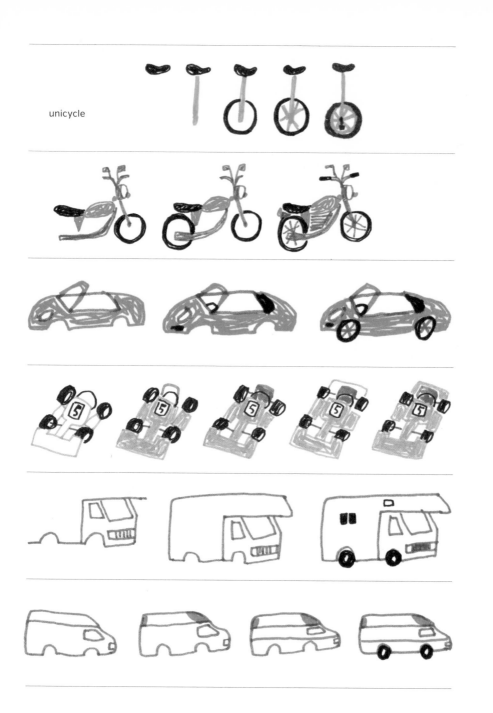

unicycle

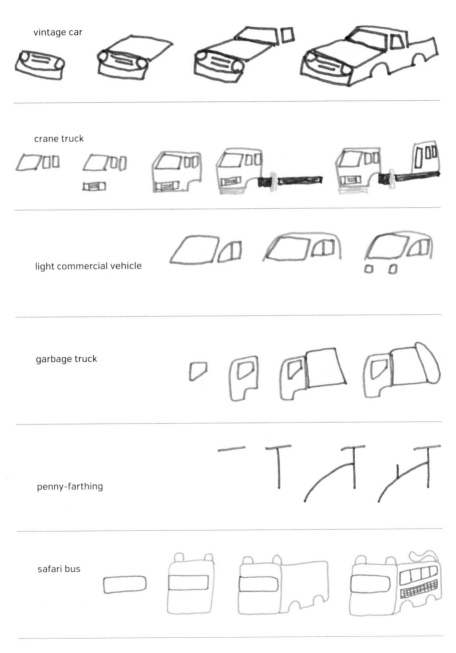

vintage car

crane truck

light commercial vehicle

garbage truck

penny-farthing

safari bus

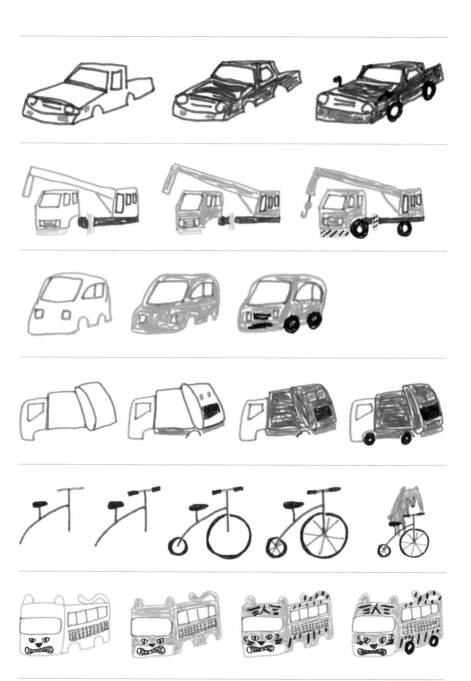

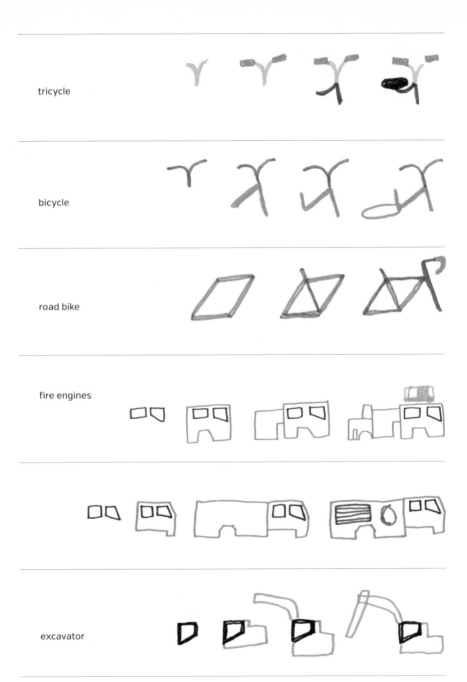

tricycle

bicycle

road bike

fire engines

excavator

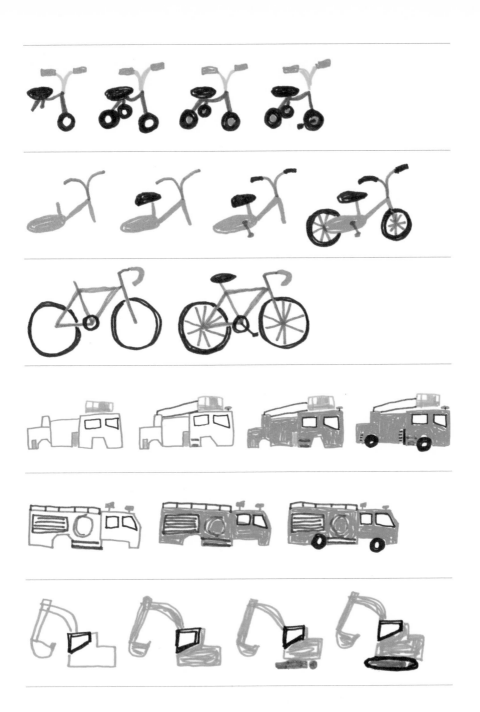

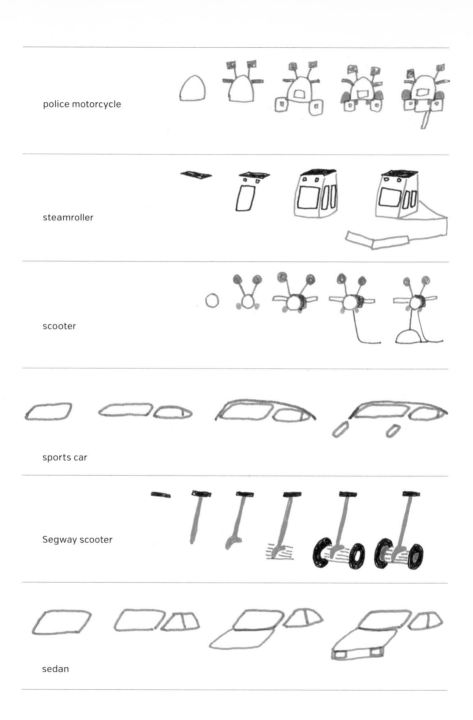

police motorcycle

steamroller

scooter

sports car

Segway scooter

sedan

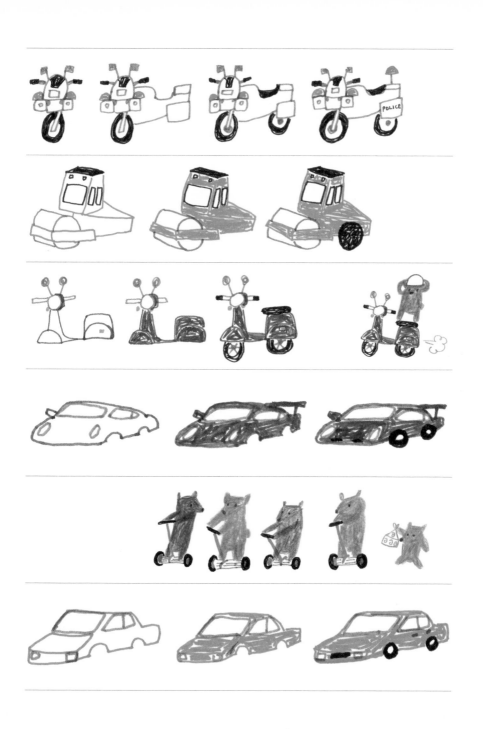

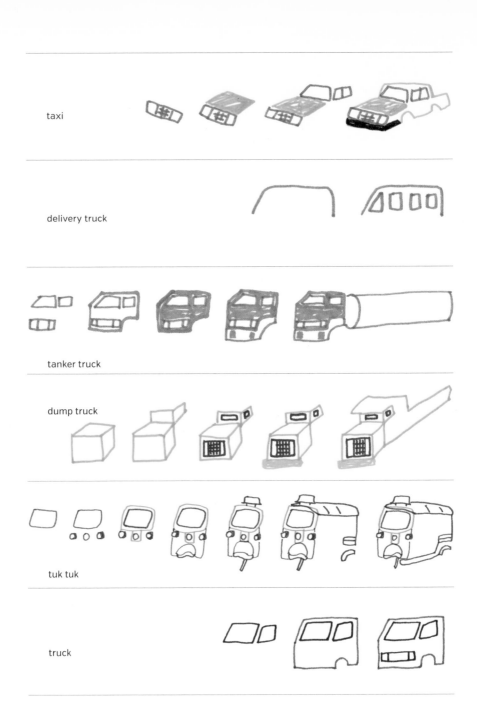

taxi

delivery truck

tanker truck

dump truck

tuk tuk

truck

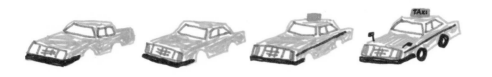

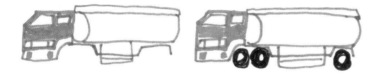

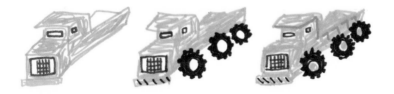

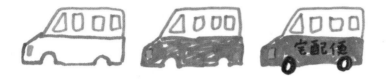

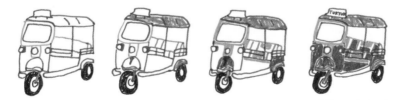

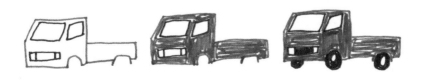

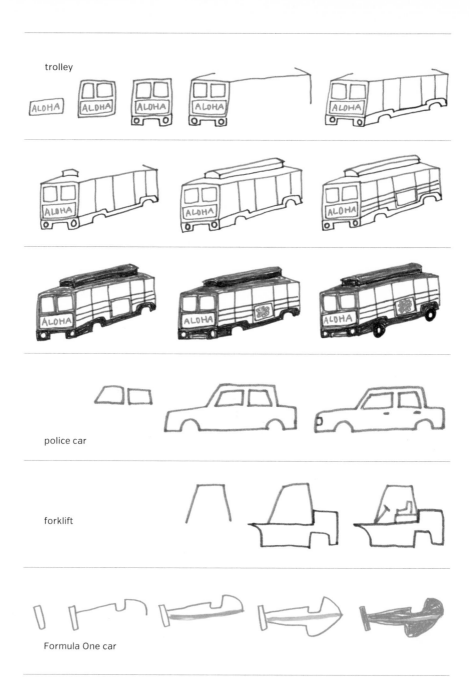

trolley

police car

forklift

Formula One car

bus

double-decker bus

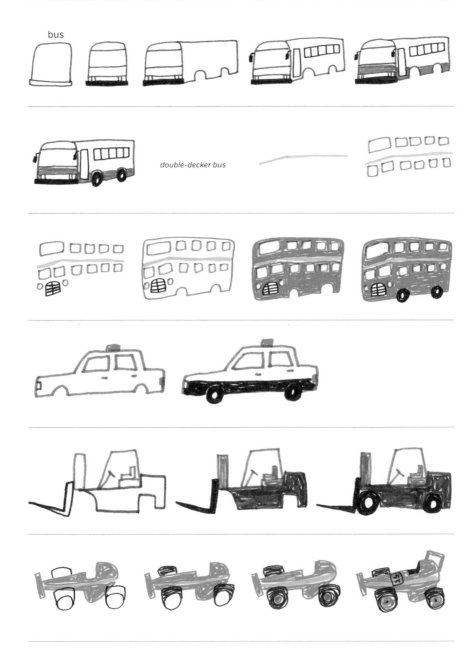

bulldozer

school bus

concrete mixer truck

limousine

van

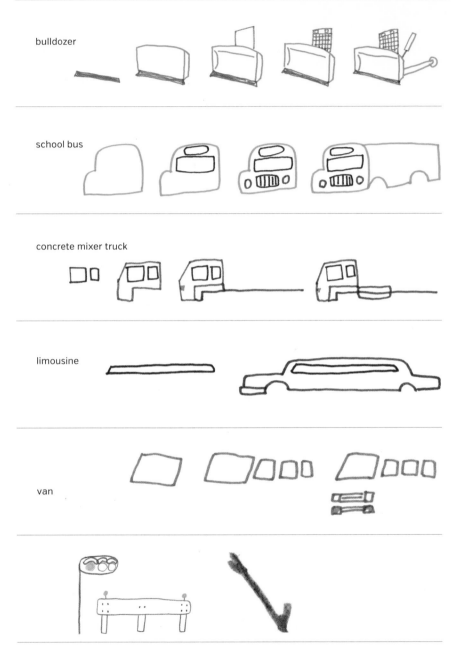

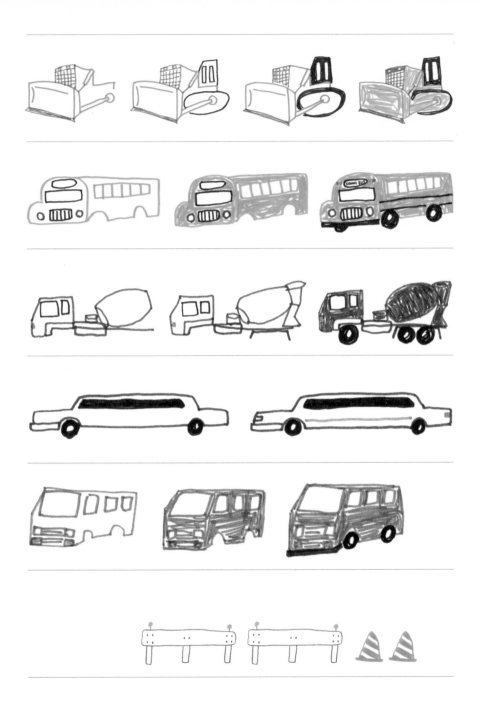

On the Tracks

When drawing a train, make the front larger and the back smaller to capture the correct perspective.

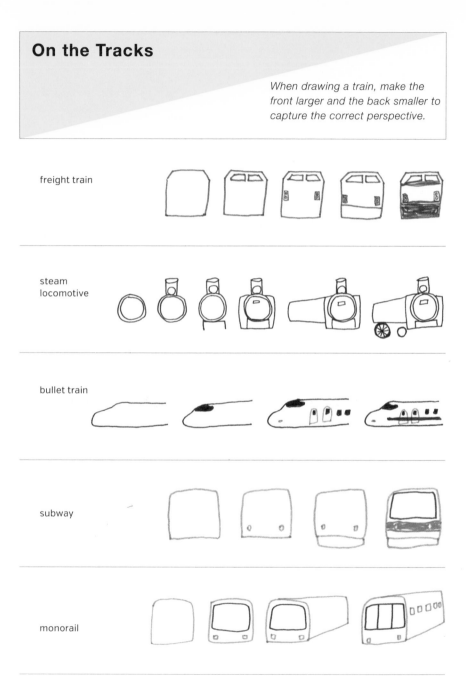

freight train

steam
locomotive

bullet train

subway

monorail

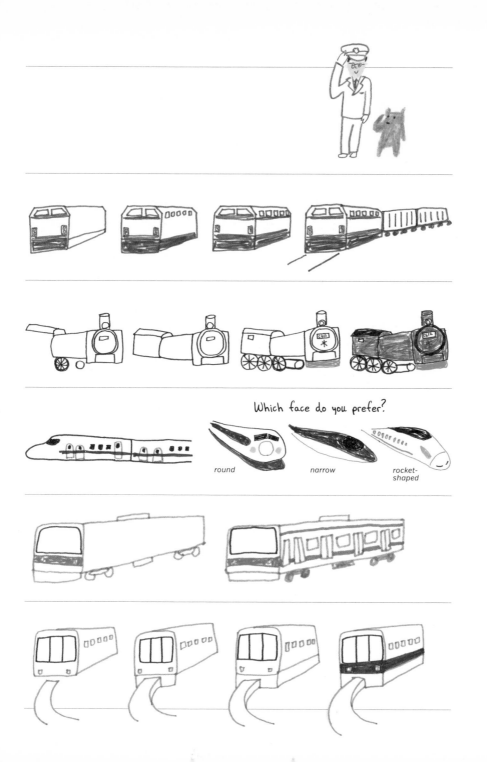

Which face do you prefer?

round *narrow* *rocket-shaped*

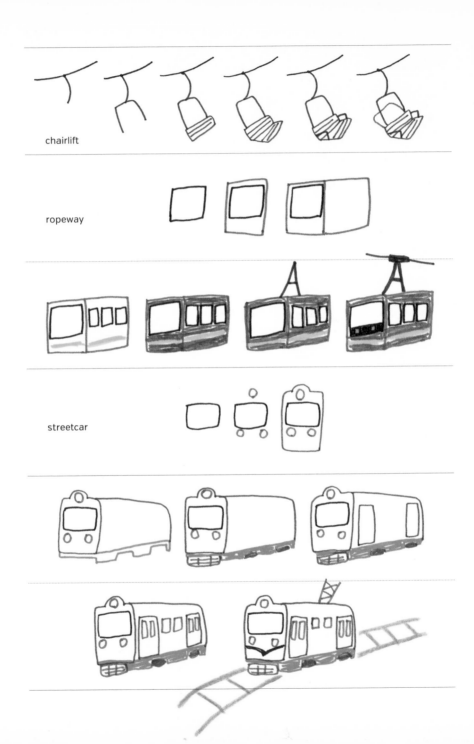

chairlift

ropeway

streetcar

In the Air

When drawing aircraft, remember that the sleeker the silhouette, the faster the aircraft can travel.

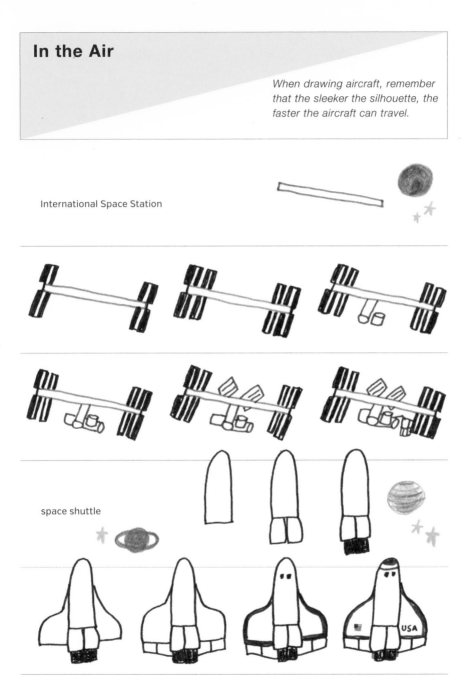

International Space Station

space shuttle

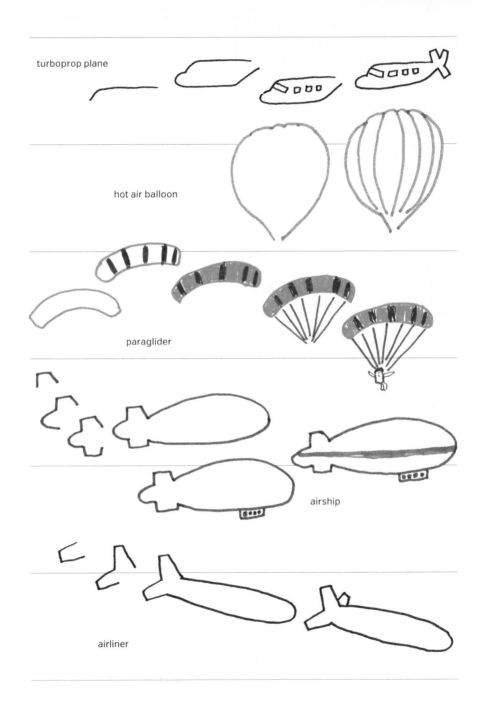

turboprop plane

hot air balloon

paraglider

airship

airliner

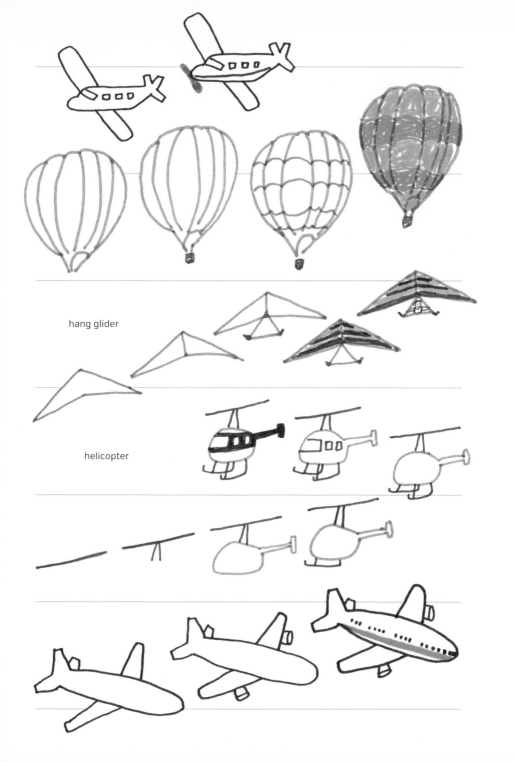

hang glider

helicopter

CHALLENGE #7:

garbage truck at the dump

Draw Vehicles and Landscapes

Although vehicles look cool on their own, they look even better in their working environments. Drawing a vehicle among its surrounding landscape also allows you to suggest motion. Use soft colors for the landscape so the vehicle will stand out.

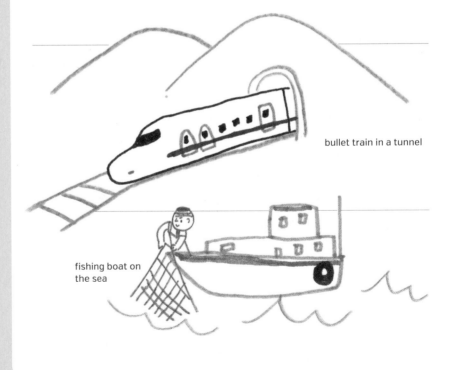

bullet train in a tunnel

fishing boat on the sea

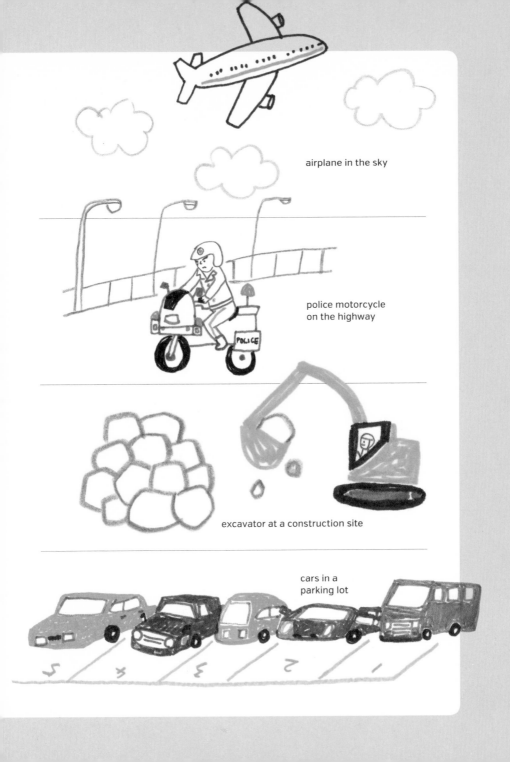

airplane in the sky

police motorcycle
on the highway

excavator at a construction site

cars in a
parking lot

On the Water

Draw sharply angled bows to suggest that the boat is moving through the water.

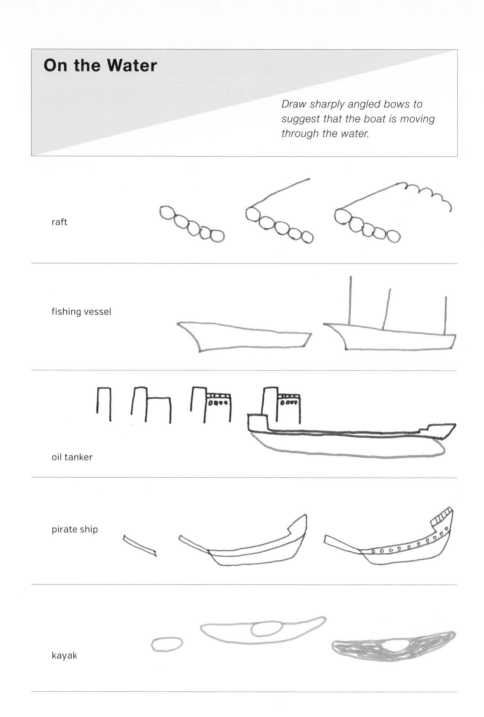

raft

fishing vessel

oil tanker

pirate ship

kayak

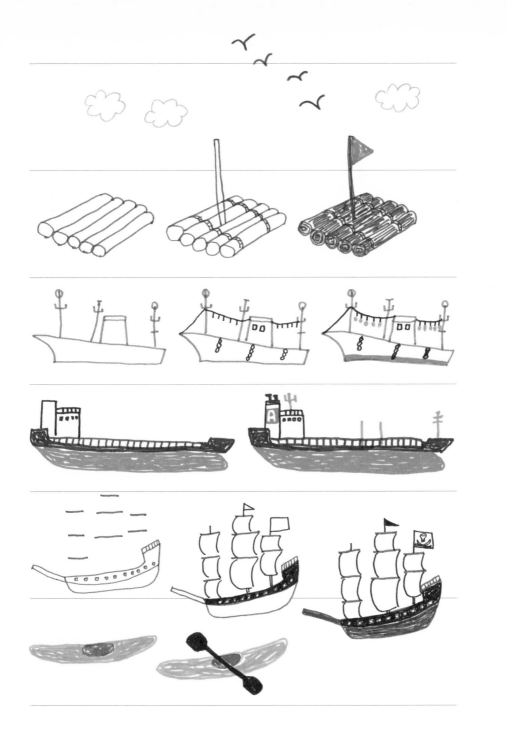

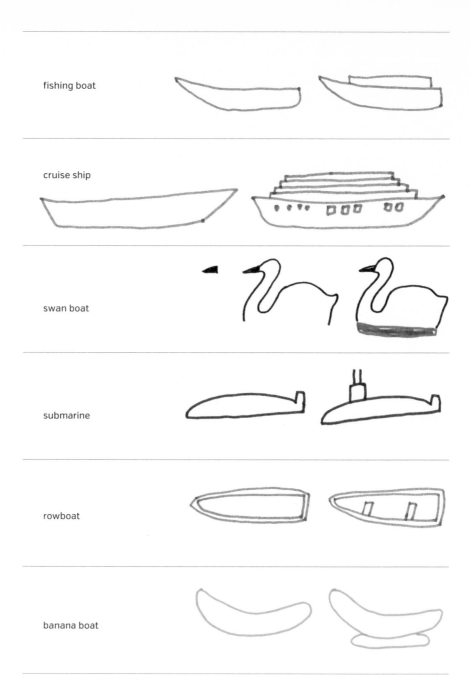

fishing boat

cruise ship

swan boat

submarine

rowboat

banana boat

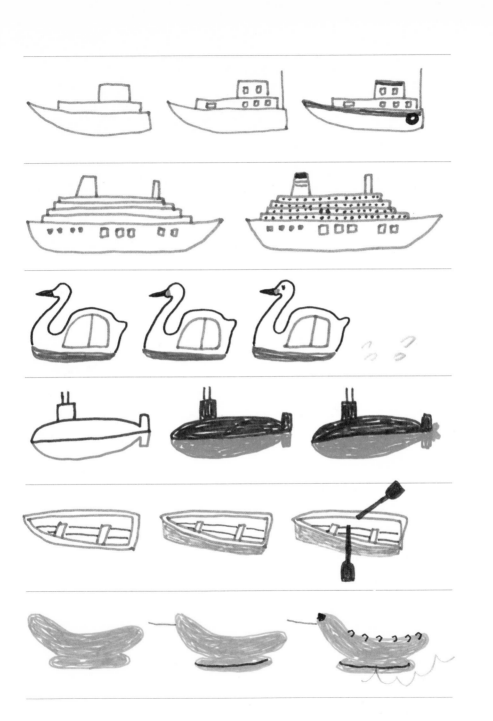

hovercraft

houseboat

sailboat

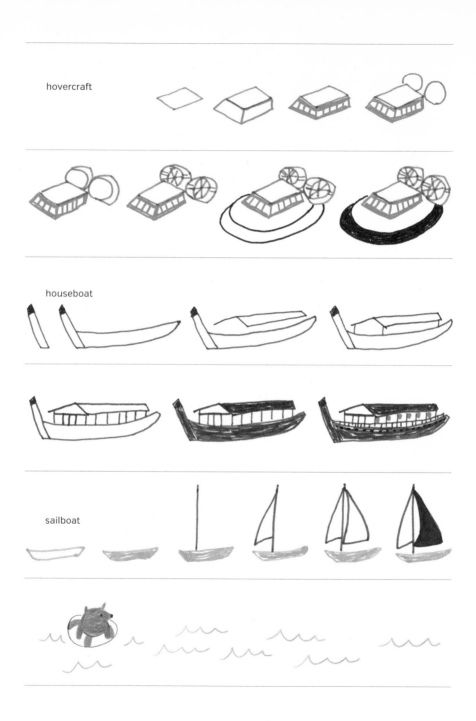

Other Vehicles

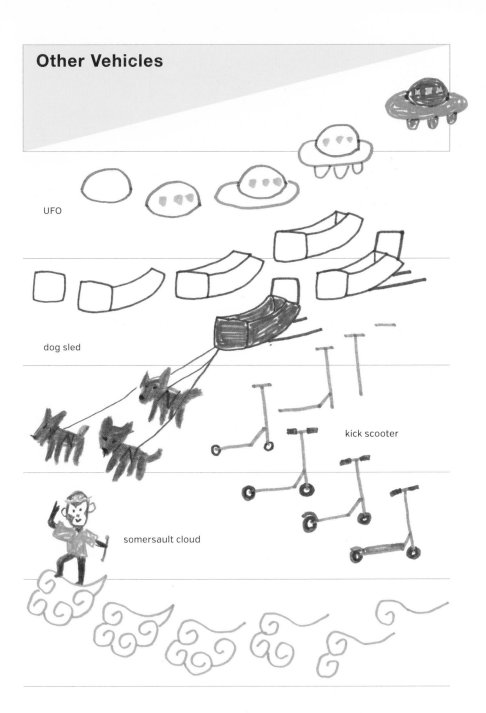

UFO

dog sled

kick scooter

somersault cloud

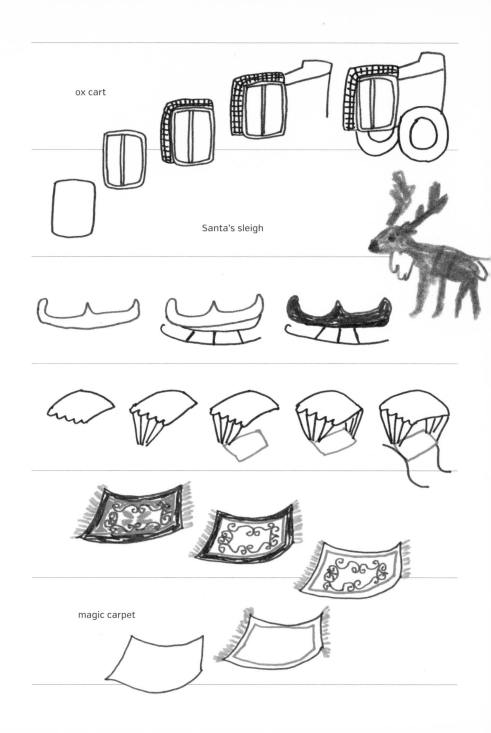

ox cart

Santa's sleigh

magic carpet

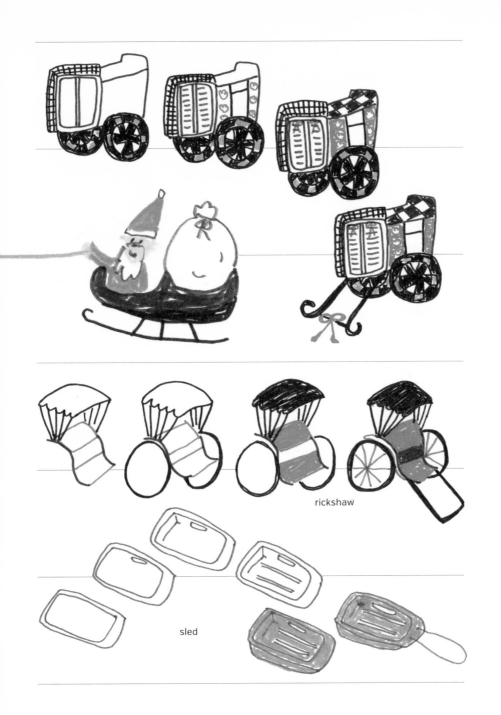

rickshaw

sled

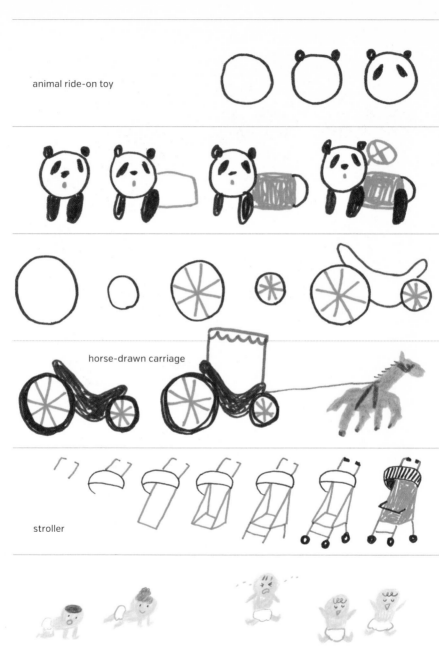

animal ride-on toy

horse-drawn carriage

stroller

Seasons

 Everyday Events

 Holidays & Seasonal Events

Weather

Chinese Zodiac

Astrological Signs

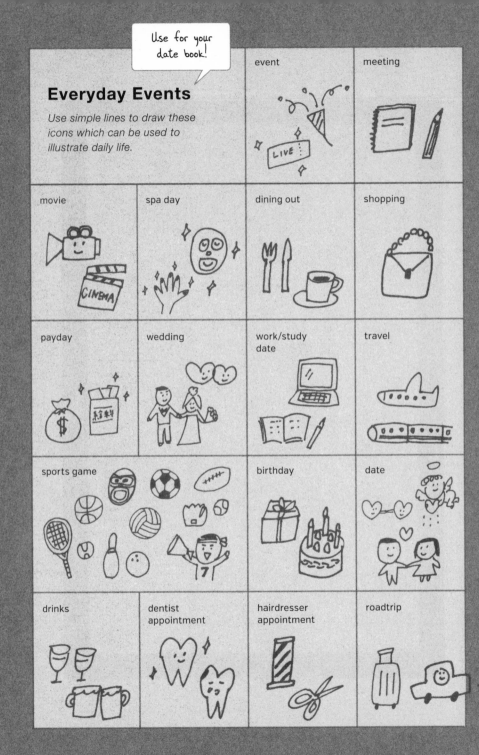

Use for your date book!

Everyday Events

Use simple lines to draw these icons which can be used to illustrate daily life.

event

meeting

movie

spa day

dining out

shopping

payday

wedding

work/study date

travel

sports game

birthday

date

drinks

dentist appointment

hairdresser appointment

roadtrip

CHALLENGE #8:

Illustrate Your Date Book

Add images to your date book or calendar when recording appointments and events. These drawings should be rough, quick sketches rather than precise illustrations. Adding art to your date book makes scheduling your time into a fun activity!

1 mon.	Coffee date at 3:00 pm
2 tue.	
3 wed.	Date night! Take Fido to the dog park!
4 thu.	Drinks at 8:00 pm
5 fri.	Movies at 9:00 pm movie
6 sat.	Dentist appointment at 1:00 pm
7 sun.	Lunch ☺ ☺ 12:00 pm
8 mon.	Trip to the zoo!
9 tue.	
10 wed.	12:30 pm Haircut appointment
11 thu.	Wedding at 3:00 pm
12 fri.	Payday!
13 sat.	Drinks at 7:30 pm

Holidays & Seasonal Events

Use these festive illustrations to celebrate the holidays. These designs can be used for greeting cards, invitations, and decorations.

Valentine's Day

weddings

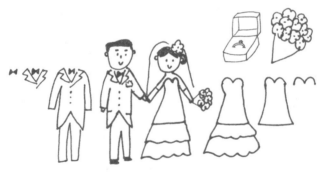

Mother's Day

Father's Day

summer vacation

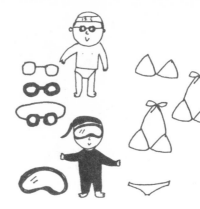

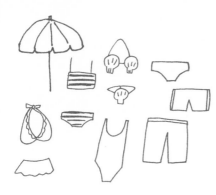

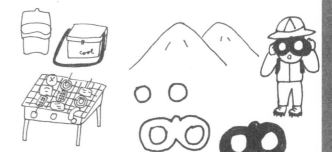

back-to-school

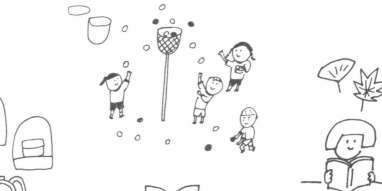

Halloween

Thanksgiving

Christmas and winter

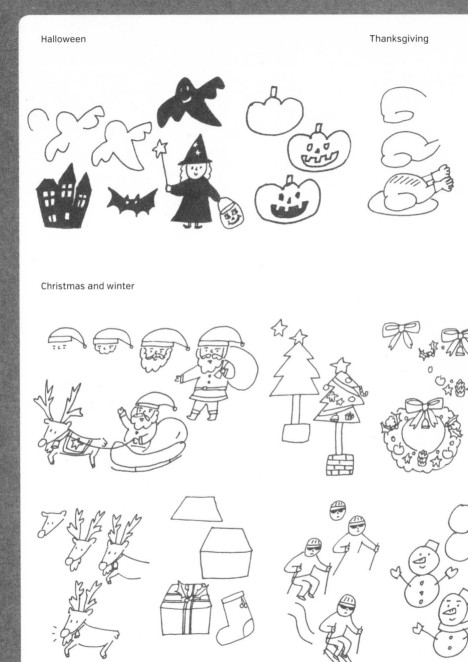

Weather

Feel free to mix and match elements from these illustrations to create different weather scenarios.

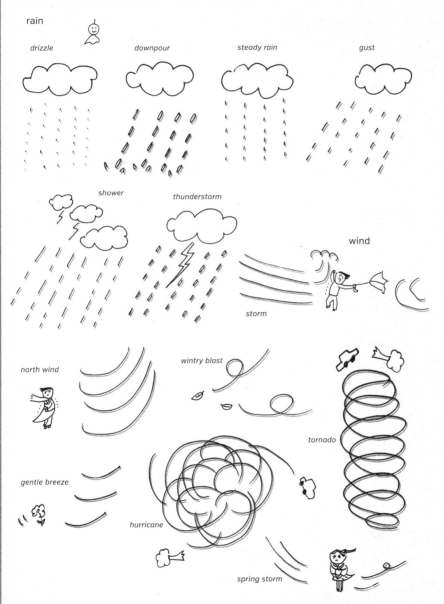

rain

drizzle

downpour

steady rain

gust

shower

thunderstorm

wind

storm

north wind

wintry blast

tornado

gentle breeze

hurricane

spring storm

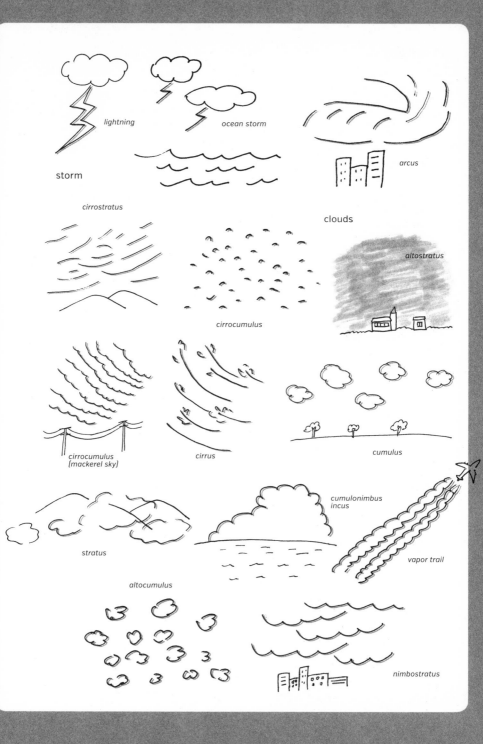

lightning

ocean storm

storm

arcus

cirrostratus

clouds

altostratus

cirrocumulus

cirrocumulus
(mackerel sky)

cirrus

cumulus

cumulonimbus
incus

vapor trail

stratus

altocumulus

nimbostratus

sun

sunrise

Indian summer sun

first sunrise of
the new year

summer sun

sunset

spring sun

snow

heavy
snow

icicles

hail

avalanche

hail
storm

sleet

moon

last
quarter

first
quarter

waning
gibbous

full moon

waxing
gibbous

waning
crescent

new
moon

waxing
crescent

Chinese Zodiac

Use a brush pen for a more traditional look.

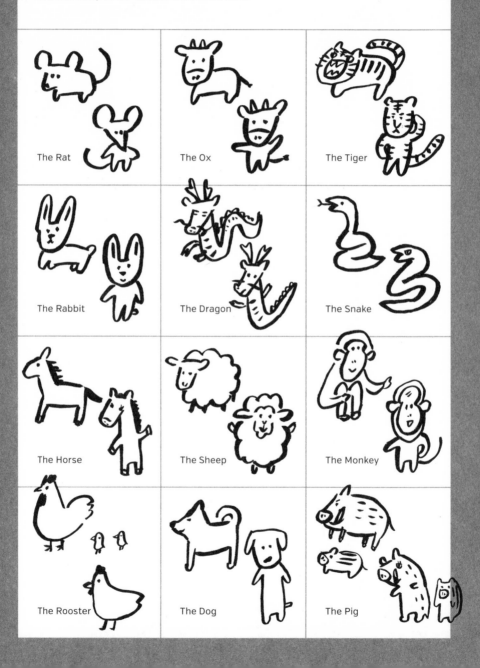

The Rat

The Ox

The Tiger

The Rabbit

The Dragon

The Snake

The Horse

The Sheep

The Monkey

The Rooster

The Dog

The Pig

Astrological Signs

There's no right or wrong way to draw these astrological signs. Feel free to take artistic liberties, just as you would when illustrating characters in a story.

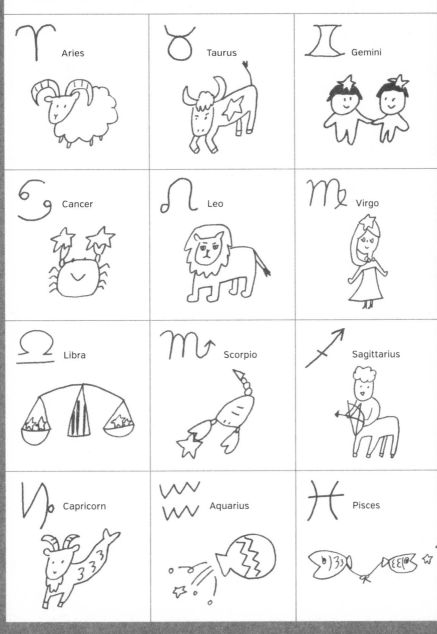

Aries

Taurus

Gemini

Cancer

Leo

Virgo

Libra

Scorpio

Sagittarius

Capricorn

Aquarius

Pisces

CHALLENGE #9:

Draw Scenes from Your Favorite Movies

I love drawing scenes from classic movies because the clothing, cars, and other props have such a unique style. Sketch scenes from your favorite movies. I've included a few of mine as inspiration.

The Godfather

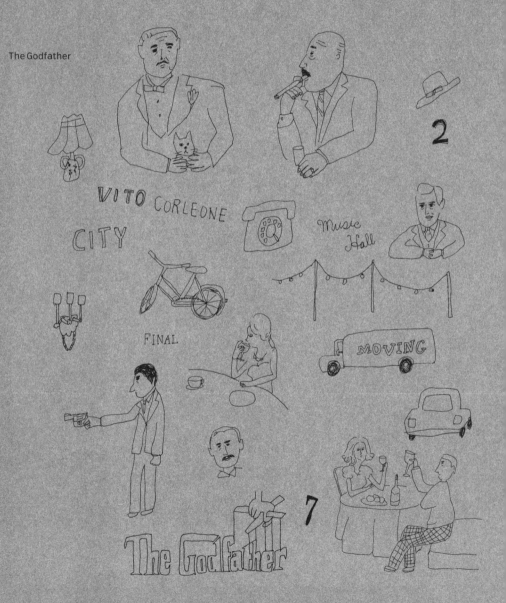

CHALLENGE #10:

Animal Alphabet

I enjoy incorporating artwork into text, so I designed this alphabet featuring animals. Feel free to use this alphabet, or have fun designing your own!

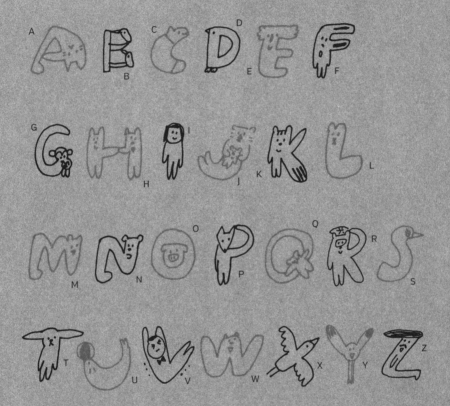

Author's Note

When I was younger, I loved to visit Inokashira Nature and Culture Park, in Tokyo. The park includes a wonderful zoo that is home to many animals, including Hanako the elephant. Every time I visited the zoo, I would always see the same man outside Hanako's enclosure. Eventually, I began drawing Hanako and her friend.

When I look back at those drawings in my sketchbook, I am filled with happiness. No two drawings look alike—each sketch features different lines, angles, and colors. It is almost as if these drawings captured my emotions at the time. To me, that is the most interesting aspect of drawing.

Have fun sketching and don't worry about perfection. In my opinion, the most interesting drawings are the ones with crooked lines or the ones with lines that extend beyond the edge of the paper. I love children's artwork because they draw without following any rules.

I will be happy if at least one person who does not consider themselves to be a good artist picks up this book and says "drawing is not so hard after all. It is actually quite fun!"

—Chika Miyata

About the Author

Chika Miyata studied illustration in college. She has worked in the advertising industry and has exhibited her work in galleries throughout Japan. Miyata has won many awards, including the Tokyo Illustrators Society Award and the Tokyo Book Jacket Illustration Competition. She is known for her cheerful drawings of animals and everyday life.

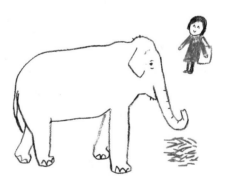

Illustration School: Let's Draw
ISBN: 978-1-59253-976-5

Drawing Cute Animals
in Colored Pencil
ISBN: 978-1-59253-936-9

Draw 500 Faces and Features
ISBN: 978-1-63159-090-0

20 Ways to Draw a Cat
and 44 Other Awesome Animals
ISBN: 978-1-59253-838-6

Fearless Drawing
ISBN: 978-1-59253-916-1

One Drawing a Day
ISBN: 978-1-59253-724-2